Fashion, Italian Style

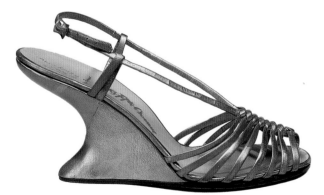

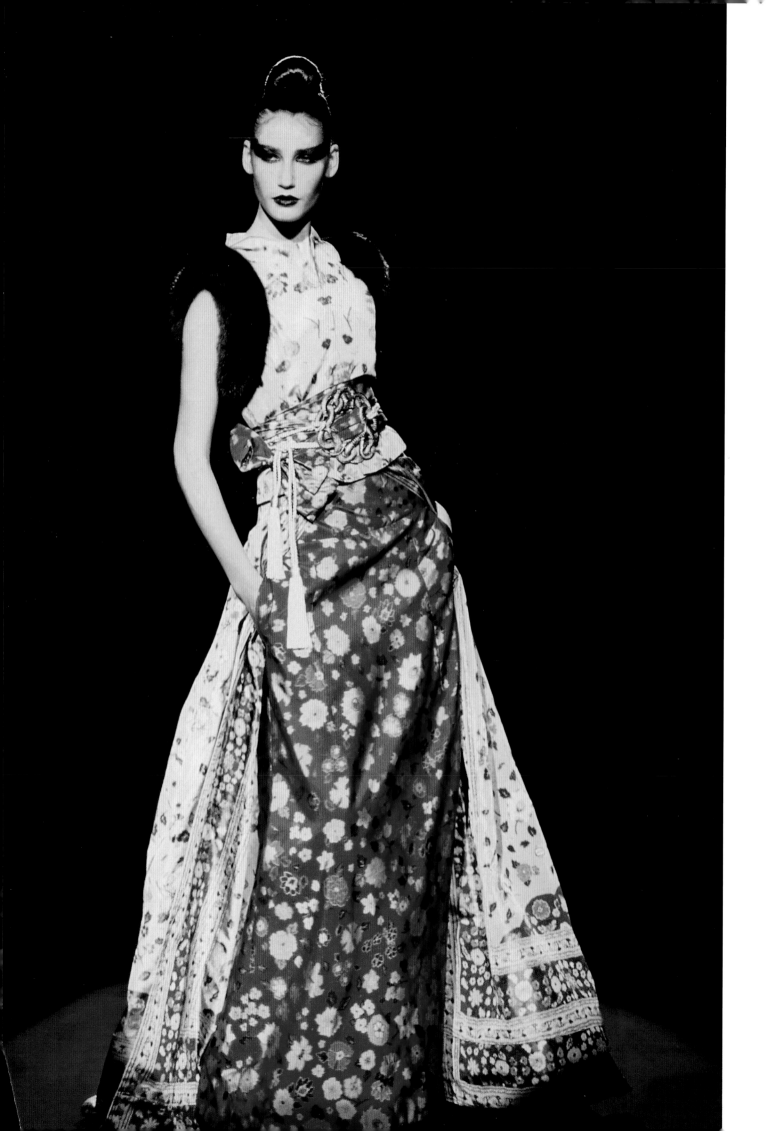

Valerie Steele

Fashion, Italian Style

Yale University Press New Haven and London

Italian Trade Commission
Government Agency

This catalogue is produced in conjunction with an exhibition at The Museum at
the Fashion Institute of Technology, New York City, made possible by the
Italian Trade Commission and Life in I Style

Designed by Gillian Malpass

Printed in Italy

Library of Congress Control Number: 2002117041

A catalogue record for this book is available from
The British Library

Page i Salvatore Ferragamo, evening sandal with sculpted wedge heel,
in gold metallic leather, c. 1949. The Museum at The Fashion Institute of Technology,
Gift of Ms. Lillian Bartok, 80.300.5. Photograph by Irving Solero

Frontispiece Valentino Couture, Fall/Winter 2002-03. Courtesy Valentino Archives

Contents

Acknowledgements

Fashion, Italian Style was made possible by the generosity of The Italian Trade Commission. Special thanks to: Georgianna Appignani, Rossana Ciraolo, Maria Ann Conelli and the graduate students at FIT, the staff of the Museum at FIT, especially Anahid Akasheh, Fred Dennis, Lynn Felsher, Glenn Petersen, Erica Portnoy, Carmen Saavedra, Tamsen Schwartzman, Irving Solero, and Jean West. Many thanks also to my co-author, Simona Segre, my editor, Gillian Malpass, and my husband, John Major – and, of course, all of the designers, manufacturers, and photographers who made this work possible.

Valerie Steele

The Italian Trade Commission – ICE would like to thank the following associations of Italian manufacturers for their collaboration in organizing the exhibition *Fashion, Italian Style*:

AIMPES
ANCI
ANFAO
ATI
CAMERA NAZIONALE DELLA MODA ITALIANA

CONFARTIGIANATO
CONFEDORAFI
FEDERORAFI
SMI-SISTEMA MODA ITALIA
UNIPRO

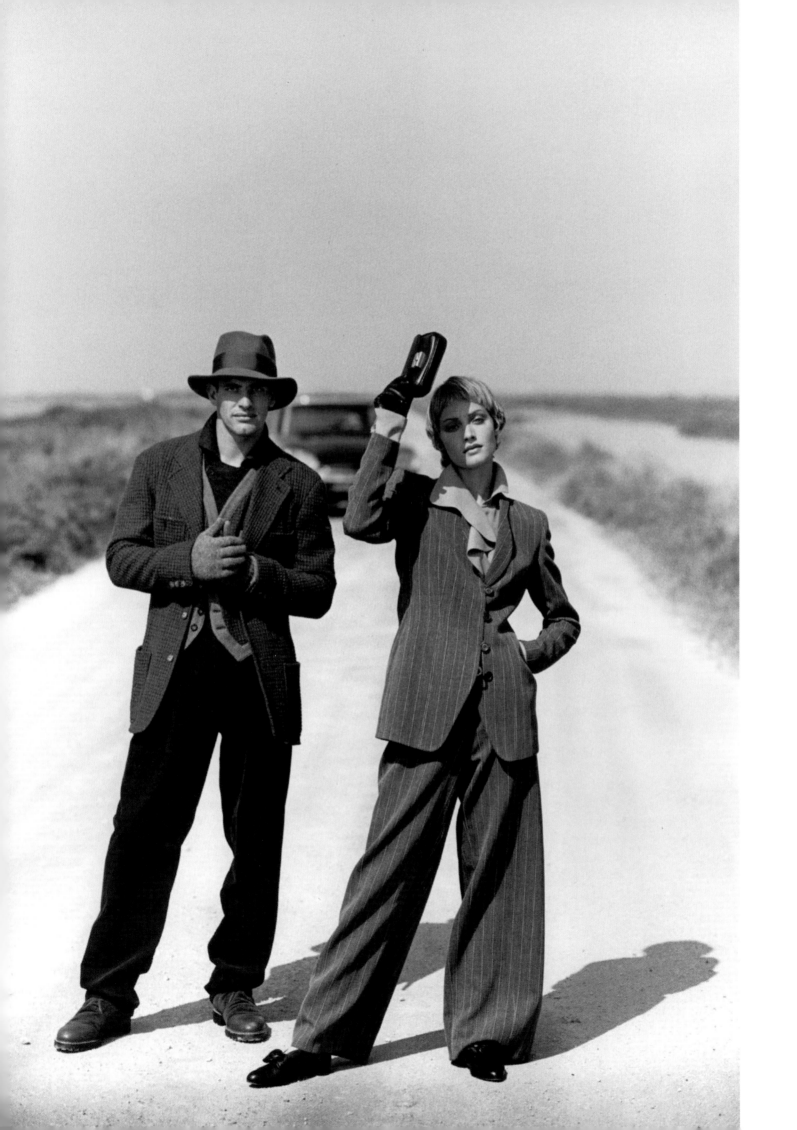

Foreword

The concept for the exhibit *Fashion, Italian Style,* which is organized by the Fashion Institute of Technology in partnership with the Italian Trade Commission (ICE), arose from a desire to celebrate Italian creativity and expertise as manifested in the field of fashion design and production. The aim is to highlight the wide range of products, from clothing to accessories that makes Italian style the ultimate trend in contemporary fashion.

This exhibit is an important part of the marketing campaign "Italia – Life in I Style" recently launched to promote Italian products and the Italian lifestyle on the U.S. market. This long-range program not only celebrates a beautiful product, whether it be a scarf, a purse, a pair of glasses, or an evening gown, it is also a wonderful opportunity to discover and celebrate the Italian flair for sophistication, exquisite craftsmanship, and technology.

It is also a cross-marketing experiment with two other important examples of Italian creativity: interior design and film. Each of these three sectors has influenced the other, each doing its part to define what is now known as the Italian Lifestyle.

This exhibition will reveal the whole process of Italian fashion, illustrating what we create and who is behind the production process, a process that incorporates the Italian tradition of fine craftsmanship with state-of-the-art technology that has put the Italian fashion industry in the vanguard. It will also illustrate how an idea, a "look," or a simple feeling has been given shape in silk, leather, or even plastic. Thanks to the contributions of each of these crafts, the sense of Italian style is appreciated and emulated worldwide.

But most of all, *Fashion, Italian Style* is an invitation to share and bring into your everyday life a feeling of beauty and a particular way of life: Italian Life in I Style.

Professor Beniamino Quintieri
Chairman,
Italian Trade Commission (ICE)

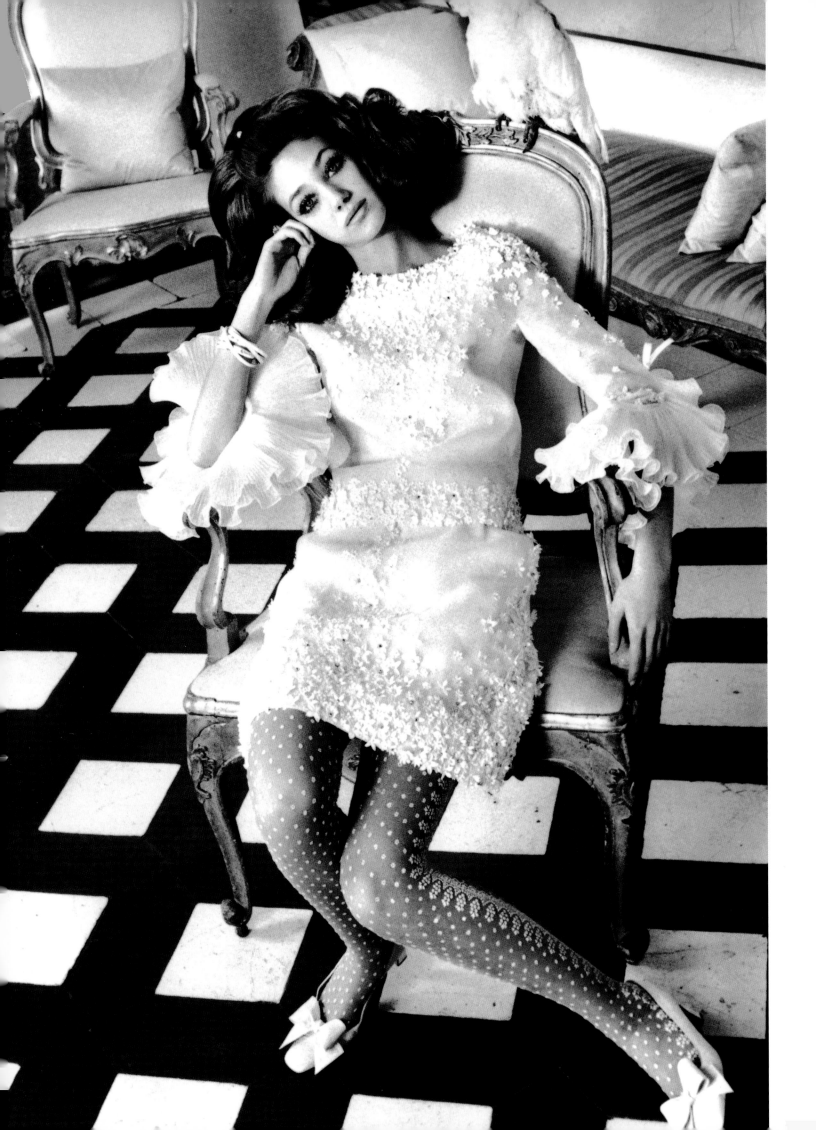

Fashion, Italian Style

Today Italy ranks with Paris and New York as one of the top three players in the world of fashion. Yet before 1945, Italy was primarily an agricultural country with an illustrious cultural history. There was essentially no industrial production of fashionable clothing in Italy, and Italian couturiers produced little that was innovative or influential. After the Second World War, Italy was in economic ruins. The rise of Italian fashion since 1945 has been nothing short of astonishing. How and why did Italian fashion become so successful so fast?

The development of a recognizable "Italian Look" is generally thought to have taken place in the late 1970s, spearheaded by designers such as Armani and Versace. However, the foundation for Italy's success began much earlier. Accessories have always played an important part in the Italian fashion system, along with a strong tradition of tailoring and textile production. Even before the Second World War, accessories by Ferragamo and Gucci were internationally famous. Italian textiles were also highly prized. But Italian fashion took a quantum leap forward in the postwar era with the reconstruction of the Italian textile industry and the rise of Italian ready-to-wear production. The commercial and cultural relationship between America and Italy played an especially important role in the development of Italian fashion.

Deeply ambivalent about French high fashion, Americans ardently embraced the casual elegance of Italian fashion. By the 1950s, Emilio Pucci's brightly colored silk fashions were icons of modern style, along with Vespa motor scooters and Olivetti

typewriters. Capri pants, sandals, gold jewelry, and chic sunglasses completed the contemporary "Italian Look." Nor was it only a question of women's fashion. Long before Armani revolutionized menswear, Italian tailors such as Brioni created jackets that were as comfortable as sweaters. By the early 1960s, it was already clear that Italy had changed the way the world looked. And this was only the beginning.

Italian style occupies a special place in the international fashion system. Yet the precise nature of the Italian contribution to international style remains elusive. Is it simply that Italian craftsmanship is superior? Is there something unique about Italian culture with which people around the world want to identify? Is it that the "Italian Look" of easy elegance has become the quintessential modern style? As Luigi Settembrini has observed, Italian style is "a difficult and intriguing problem . . . which is constantly in danger of foundering on the stereotypical reefs of 'national characteristics of peoples.'"[1]

According to Gianino Malossi, many Italians believe that "Italy is the country of elegance." Italians are fascinated by the idea of *la bella figura*, which they associate with "the aptitude for seduction and the pleasure taken in living." As Malossi writes, "The very idea of belonging to an elegant and seductive nation . . . whose success is based on elegance, arouses a feeling of satisfaction and confidence in the average Italian. This positive attitude toward the question of elegance has made a far from insignificant contribution to the development of the commercial myth of Italian fashion. And the success of this myth, in turn, has strengthened its grip on the public."[2]

But the success of Italian fashion is no myth. The significance of Italian cultural history – including, perhaps, a special feeling for elegance and sensuality – should not be minimized; but the triumph of Italian style derives in large part from a uniquely Italian model of the fashion industry, quite different from that in other countries. It is immediately apparent, for example, that the family unit remains an important feature of the Italian fashion system. Craft traditions also remain strong. At the same time, the most up-to-date technology is readily available. Cities such as Florence, Rome, and later Milan have all been important fashion centers, but the geography of Italian fashion covers a large area, and different regions of Italy specialize in different materials and goods. In addition to the regional segmentation of production in specific geographic areas known as "the Districts," the Italian fashion system is characterized by the vertical integration of production from fiber to finished item. Other countries have tried to replicate the Italian model, but, for reasons that will become apparent, it remains inimitable.

From the Roman Empire to the Venetian Republic

The history of Italian fashion reflects the long and complicated history of Italy itself. Whereas Paris has been the political, economic, and cultural capital of France for centuries, the same can not be said about the role of Rome in Italy. In the ancient world, of course, Rome was the capital of an enormous empire, and the toga became standard male attire for members of the ruling class. Luxury goods such as silk were imported into Rome from as far away as China. But with the collapse of the Roman Empire, the Italian peninsula ceased to have a unified political structure. Rome itself experienced innumerable vicissitudes, although it remained the center of the Roman Catholic Church. Moreover, while classical dress continued to provide a certain prototype for ecclesiastical and legal dress, it differed in significant respects from the regular pattern of stylistic change that characterizes modern fashion, a phenomenon that most historians agree developed in Europe during the late Middle Ages and the Renaissance.

Can we then say that Italian fashion began in the Renaissance? Certainly, Italian city-states, such as Florence and Venice, played a vital role in the emergence of modern fashion during the Renaissance. Fashion requires a particular social and economic structure within which it can flourish, and a type of proto-capitalism

conducive to the rise of fashion developed very early in several of the Italian city-states. In addition, textile trade and production form the material foundation for fashion, and textiles were one of the chief commodities traded by Italian merchants in the Middle Ages.

Italy's geographic position placed it at an advantage for trade. By the twelfth century, Venice, gateway to the Orient, was one of Europe's most fashionable cities. The Venetian merchant Marco Polo traveled as far away as China, but most Italian trade in silk was with Byzantium and Persia. Sicily was among the earliest centers of artistic weaving and sericulture in Italy, both under the period of Arab domination and after the Norman conquest of Sicily in the twelfth century. The merchants of Lucca and Venice also began manufacturing silk textiles based on imported Eastern models. When Pisa conquered Lucca, many silk weavers moved to Florence, Venice, and Bologna. By the fourteenth century, Florence was producing some of the world's best woolen cloth, with fleece purchased from England and Portugal. By the fifteenth century, Italian weavers had mastered the technology required to produce patterned velvets. Italian textiles were highly sought after throughout Europe. Renaissance art testifies to the creativity and technical skill of Italian weavers and other artisans. The Medicis, art patrons and rulers of Florence, began as wool merchants and money lenders. Some important names in contemporary Italian fashion also date from the Renaissance. For example, in 1586, the Boselli family were silk merchants, and today Mario Boselli is head of the Camera Nazionale della Moda Italiana.

Among the fashion trades in Venice between the thirteenth and the eighteenth centuries were the shoemakers and cobblers, tanners and other leather workers, silk weavers, wool spinners, cotton and linen weavers, dyers, tailors, furriers, haberdashers, embroiderers, ribbon and braid makers, button makers, and makers of spectacles. Until the fall of the Venetian Republic – the Serenissima – these trades were organized into guilds. Although the guild system worked well for centuries, by the Napoleonic period it was no longer economically competitive. However, the persistence of craft traditions would later play an important role in the rise of Italian fashion.

Historical forces delayed the subsequent development of a unified nation state in the Italian peninsula. As a result, other nations, especially England and France, moved ahead of a still-divided Italy. One of the consequences was that by the eighteenth century, Italian fashion had become derivative of French fashion (for women) and of English tailoring (for men). Beautiful clothes were still produced in Italy, as can be seen in eighteenth-century paintings produced in Venice and Rome, as well as in surviving examples of clothing; but the dominant trends in fashion were set elsewhere. Regional costume enjoyed a revival throughout western Europe in the eighteenth and nineteenth centuries, and Italian folk dress, in particular, was much appreciated by artists, but folk costume was marginal to the course of fashion history, which was essentially the history of urban dress.

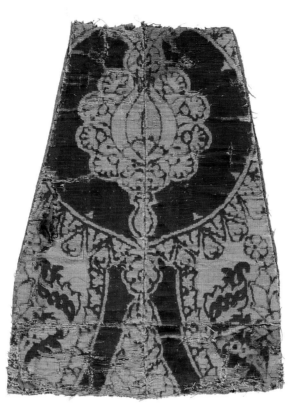

Textile from Italy, possibly
Florence, late fifteenth/
early sixteenth century. Silk
velvet, cut and voided pile
with gold metallic wefts.
The Museum at
The Fashion Institute of
Technology. Photograph by
Irving Solero

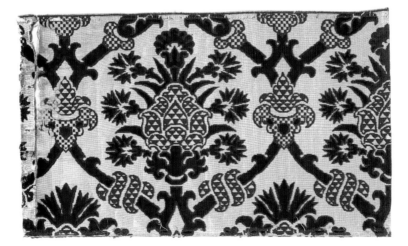

Textile from Italy, possibly
Florence, late sixteenth/
early seventeenth century.
Ciselé velvet, cut and uncut
voided silk pile on silver
metallic ground. The
Museum at The Fashion
Institute of Technology.
Photograph by Irving
Solero

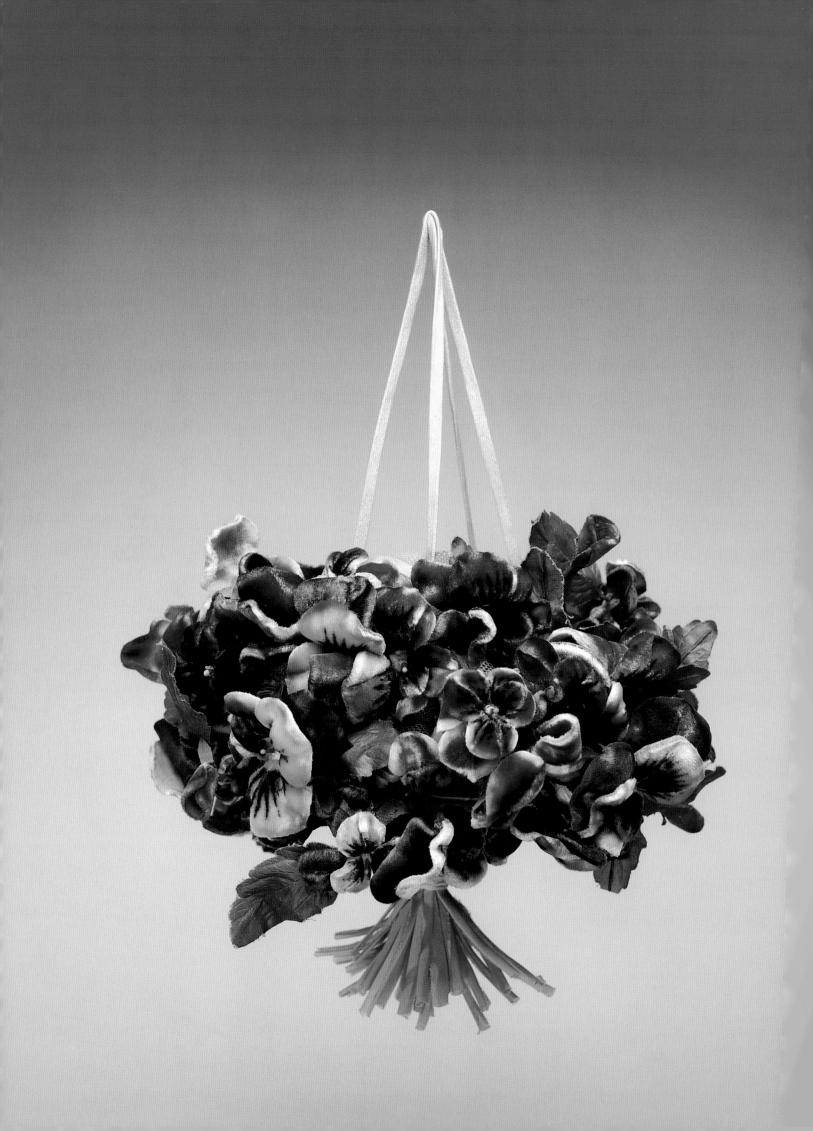

Art and Industry in the Early Twentieth Century

With the rise of the haute couture in nineteenth-century France, Italian fashion fell further into a subordinate position vis-a-vis Paris, the international capital of fashion. It is true that Italy continued to be recognized for its textiles and elegant craftsmanship. Italian artisans were, in fact, often employed by French couture houses to do fine handwork, such as embroidery, and to create accessories, such as shoes and lingerie. Indeed, by the beginning of the twentieth century, Italian accessories were world famous. But a pair of shoes and an elegant handbag have always been regarded as secondary to the dress, and the dominant aesthetic of Italian fashion was for many years derived from the French couture.

There were a handful of exceptions. Mariano Fortuny (1871–1949), a Spanish-born creator of textiles and clothing, established a business in Venice in the late nineteenth century, producing a unique type of avant-garde fashion. His choice of Venice as a residence seems to have influenced his work, for Venice is the most "Oriental" city in Italy, and Fortuny's fabrics frequently utilize Ottoman-style motifs. But although much admired by fashion connoisseurs like Marcel Proust, Fortuny's elegant pleated dresses and sumptuous mantles were essentially only an artistic alternative to fashionable dress. The same conclusion applies to the artistic textiles and clothing created by Maria Monaci Gallenga (1880–1944).

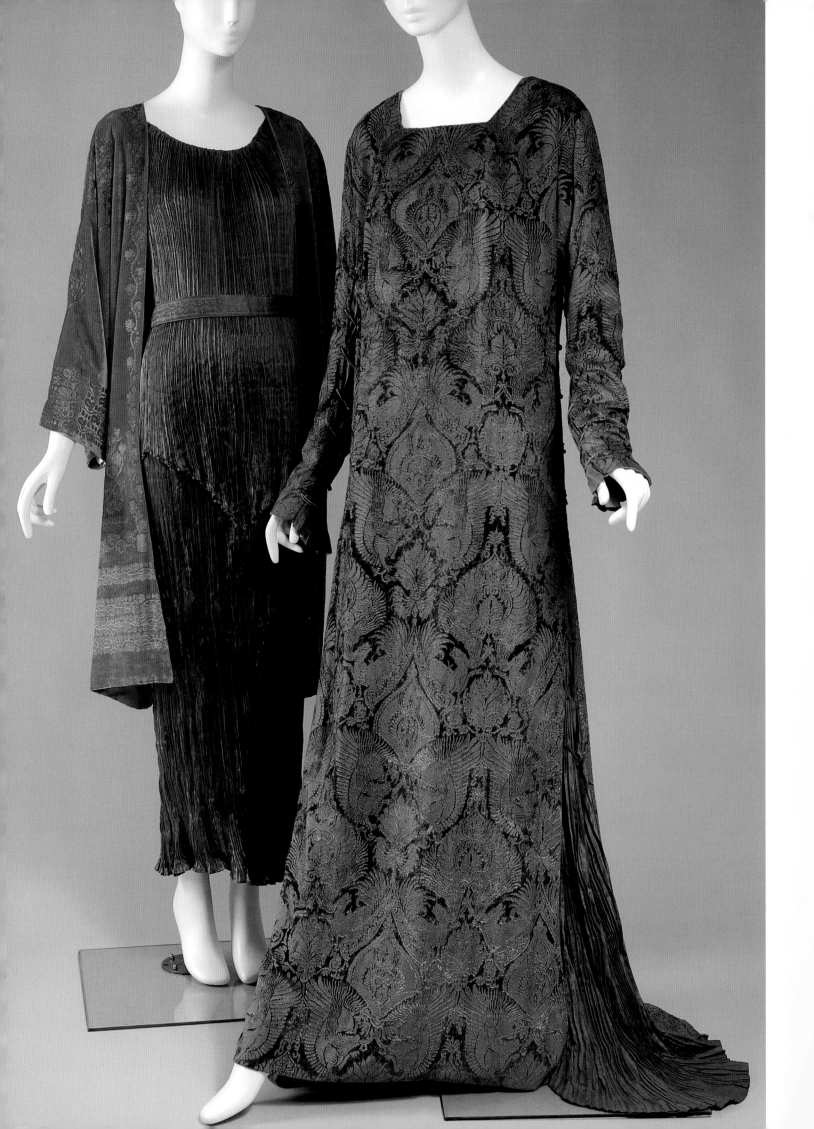

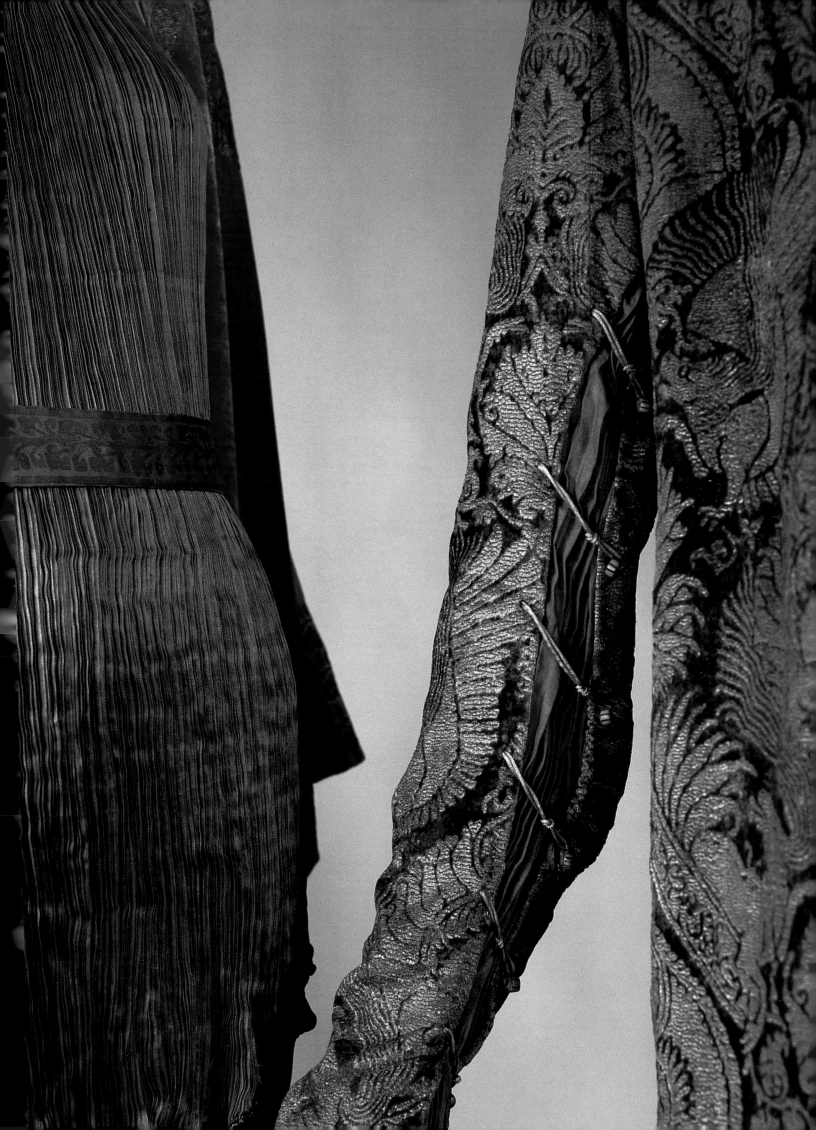

More significant historically was the steady evolution of quality as the leitmotif of Italian textiles and accessories during the period of transition from purely artisanal production to a modern industrial system. Silk weaving in Como began to be industrialized at the end of the nineteenth century. Mechanical looms and a factory system steadily replaced preindustrial workshops, but an emphasis on artistic design maintained a high standard of quality. Italian silks by companies such as Boselli and Ratti were highly prized throughout Europe, and were often utilized by Paris couturiers.

Menswear fabrics were also important. In 1836, Luigi Marzotto founded a textile company in Valdagno, a town near Venice with a tradition of wool-making that dated back to the Middle Ages. Over the next century and a half, Marzotto expanded from one small mill to become a major industrial group of companies producing yarn, fabric, and apparel. In 1912, Ermenegildo Zegna started a company in Trivero, a village in the Alpine foothills, with the aim of producing the world's best menswear fabrics, superior even to the legendary English woolens. He selected the best raw materials, invested in modern technology, and developed an internal creative design group, with the result that by the 1930s Zegna fabrics were internationally recognized. Many such examples could be given.

Accessories also flourished. Some of the most famous names in Italian fashion can trace their heritage to the beginning of the twentieth century. Gucci, for example, was founded as a saddlery shop in 1906 by Guccio Gucci. In 1923, he opened an accessory shop in Florence which quickly became known for handbags and other leather accessories.

Salvatore Ferragamo (1898–1960) was born in Bonito, near Naples, and learned the basic skills of shoe production while apprenticed to a local cobbler. In 1914, he emigrated to the United States, where he pursued his studies of shoe design and construction, establishing a business in California that attracted the attention of numerous celebrated clients. He returned to Italy in 1927 and set up a workshop in Florence which was soon to become one of Italy's most important fashion cities. There he created many innovative and influential shoe styles.

The cultural significance of fashion was certainly recognized by Italian artists and intellectuals. Fashion was made the central part of the Futurists' plan to remake not only art but life. The celebrated Futurist manifesto of 1914, *Anti-Neutral Clothing*, was intended to "color Italy with Futurist daring and risk, at last giving Italians combative and playful clothing." Clothing was to be "aggressive, so as to increase the courage of the strong and to upset the sensibilities of the cowardly, lending agility . . . to add impetus in struggle, in the running or charging stride, strong willed . . . like orders on the battlefield . . . Futurist shoes will be dynamic, different one from the other, in shape and in color, suitable for cheerful kicking . . ." As early as 1912, Giacomo Balla

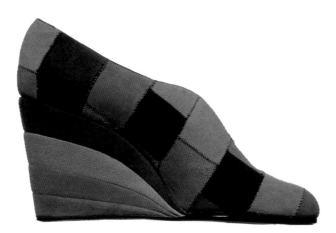

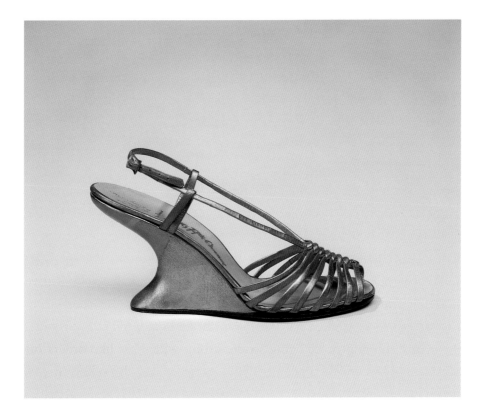

had created Futurist men's clothing in bright colors and bold patterns, designed to overthrow bourgeois propriety. "One thinks and acts as one is dressed," declared Balla. A year later, in the manifesto *Futurist Reconstruction of the Universe*, Balla proposed transformable garments with mechanical additions.[3]

Some of the same themes recur in the *Manifesto of Futurist Women's Fashion* of 1920, which argued that "Women's fashion has always been more or less Futurist. Fashion [is the] feminine equivalent of Futurism. Speed, innovation, courage in creation . . . Futurist women will need to have, in wearing the new styles of clothing, the same courage as we had in freely declaring our words, in the teeth of the recalcitrant ignorance of the public in Italy and abroad. Women's fashion will never be extravagant enough . . . We shall create illusionistic sarcastic sonorous noisy deadly explosive outfits: spring outfits jack-in-the-box outfits changeable outfits, equipped with springs, strings, photographic lenses, electric currents, reflectors, perfumed fountains, fireworks, a thousand gadgets capable of playing the dirtiest tricks and pulling the most disconcerting pranks on clumsy suitors and sentimental lovers."[4] In 1919, the Futurist illustrator Ernesto Thayaht designed unisex overalls for men and women. A decade later, he called for clothing that would be "simpler and more practical than the current style." Thayaht wrote, "Let new Italian fashion . . . be courageous and be a Futurist fashion, a simplified, adventuresome, and colorful fashion."[5]

The first internationally famous Italian fashion designer was Elsa Schiaparelli (1890–1973), who was born in Rome in the Palazzo Corsini to a family of intellectuals. Significantly, however, Schiaparelli became famous only after she established a couture house in Paris, from which city she achieved the international recognition denied to designers based in other countries. Believing fashion to be an art form, Schiaparelli often collaborated with other artists, such as Salvator Dali and Jean Cocteau. Together, they created striking Surrealist fashions such as the Shoe Hat and the Tear Dress. During the Second World War, Schiaparelli fled to the United States, but she continued to insist that "It is not possible for New York or any other city to take the place of Paris."[6]

The Fascist regime insisted, to the contrary, that Italian fashion should be national in character, drawing inspiration from ancient Rome, regional folk costumes, and the fashions of the Italian Renaissance. (The Nazi regime in Germany made similar claims, denouncing international, cosmopolitan fashion.) Mussolini's government established a National Fashion Office in Turin, advocating an Italian style. In 1942, the magazine *Bellezza* echoed the official line, arguing that "Many people . . . thought that real elegance could only reach the Italian woman from across the Alps (France) or across the ocean (the United States) . . . To continue on this path would not have been useful to Italy's economy. The War put up barriers between Italy and those who considered themselves to be the center of international fashion. These barriers

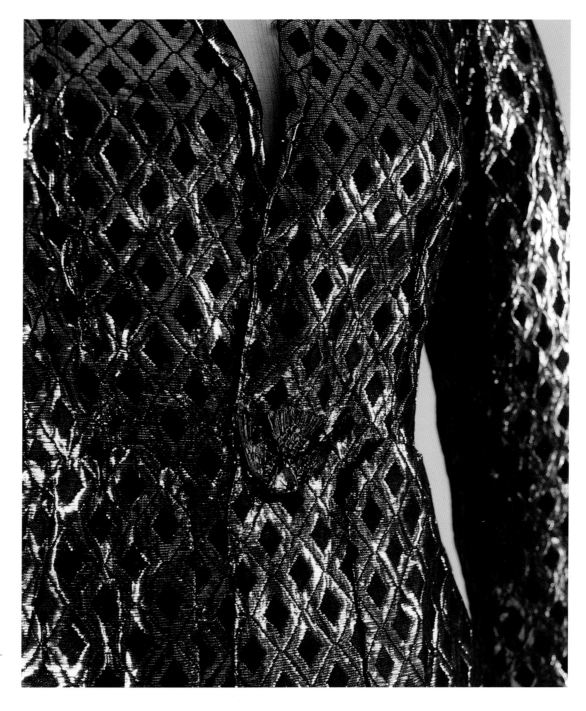

ELSA SCHIAPARELLI
Lamé evening jacket in
rose lurex and black
woven losenge pattern
with a blue enameled bird
button, Fall/Winter
1937–38. The Museum at
The Fashion Institute of
Technology, 2000.75.1. Pho-
tograph by
Irving Solero

acted like a green house and gave Italian fashion the strength to blossom."[7] Despite
nationalist propaganda, however, fashion in Italy continued to be derivative. The
autarchical economic policies of the Fascist government and the outbreak of war
severely crippled the Italian fashion industry. Raw materials became increasingly
difficult to obtain, while production and exports plummeted. The American market
for Italian goods disappeared.

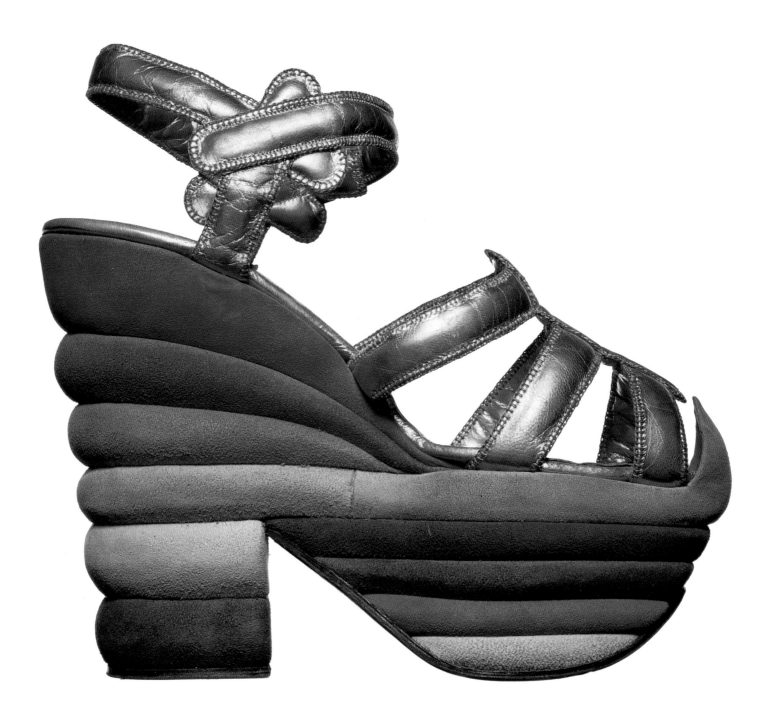

Reconstructing Italian Fashion

The development of an authentic Italian style and a modern fashion system occurred only after the Second World War, within the context of a new international fashion system. Moreover, fashion played a cathartic (and highly visible) role in Italy's economic Reconstruction. "Italian fashion regained its economic and cultural strength as early as 1946, and it went on to achieve a series of successes in the atmosphere of active transformation that characterized the period just after the war," observes Ornella Morelli.[8] Although Italian clothing and accessories had been exported to the United States since the 1920s, there now developed a much more extensive commercial and cultural relationship between the two countries.

In her book, *Reconstructing Italian Fashion: America and the Development of the Italian Fashion Industry*, Nicola White describes the "vital role" played by America. The Marshall Plan, of course, had a significant impact on Italy's Reconstruction, by providing financial assistance, but, according to White, there were many aspects to American influence on the regeneration of the Italian textile and clothing industries. "Firstly, through initial financial support and close involvement with the industrial organisation of Italy; secondly, as a supplier of progressive manufacturing methods; thirdly as a cultural model; and fourthly, as a keen market."[9] Economic relations between America and Italy were facilitated by the existence of a substantial Italian–American community in New York.

Many Italian companies actively pursued the American market. Their initial emphasis was on prewar Italian export items, such as textiles, shoes, and handbags;

but this soon expanded to clothing fashions as well. Within Italy, leading textile manufacturers and financial groups based in central and northern Italy invested heavily in the revival – and modernization – of the clothing industries. For example, modern dress forms ("dummies") with collapsible shoulders and precise measurement marks were imported from the United States to facilitate international trade. Italian textile producers also actively promoted Italian fashion and often created innovative and exclusive fabrics for individual designers and clothing manufacturers. Although Italian designers and manufacturers did not pay for advertising in the American press, they found other ways to promote their country's sense of style.

The Nazi Occupation of Paris during the war had disrupted the centuries-long tradition of French fashion dominance. With Paris temporarily out of the picture, the United States made rapid progress in developing its own style of sportswear, which became an important influence on postwar Italian fashion. After Liberation, Paris regained its dominant position in the world of fashion. Yet beneath the surface, the French were struggling with the historic transition away from the couture towards ready-to-wear fashion. The buyers for American department stores initially promoted Italian-made goods as an inexpensive alternative to French fashion, but the triumph of "Made in Italy" rapidly developed from a synonym for "cheap" into an exploration of uniquely Italian contributions to fashion.

One way that Italian fashion designers and entrepreneurs sold the idea of Italian fashion was by emphasizing its aristocratic associations. American journalists responded by enthusiastically promoting the "Italian Look," albeit through a veil of stereotypes. *Vogue*, for example, identified Italian fashion with the seductive and aristocratic Italian woman: "The sophisticated Italian woman has, at the outset, two great advantages: Wonderful materials and an apparently inexhaustible pool of hand labor. The Italian woman of breeding also has a certain quality of relaxation (not unnatural since she seldom works) which endows her clothes with an easy grace, a free, uninhibited movement. Her thonged sandals help too, for her legs and feet are possibly the best in Europe."[10]

Imagination, however, was still seen as an attribute of the French couturier. "Italian clothes are inclined to be as extrovert as the people who wear them . . . gay, charming, sometimes dramatic, but seldom highly imaginative or arresting," continued *Vogue*. On the other hand, Gucci's prestigious bucket bag and Ferragamo's shoes were praised, as were sexy Italian playsuits: "little-girlish but in no way innocent." And the prices (about $100 for a day dress and $200 for an evening dress) "are far lower than in Paris."[11]

Not only did Americans perceive the Italians as sexy and elegant, they also envisioned Italy itself as a desirable tourist destination, thus enhancing the "souvenir effect" of Italian fashion. Another article in *Vogue* entitled "Italian Ideas for Any

South" promoted Italian "sun clothes" as chic and stylish. The allure of the Italian woman was again emphasized: "It's a game they play in the European resorts – guessing how many well-dressed women are Italians."[12]

The visual spectacle of the fashion show provided another means of promoting Italian design. Although the Italians might not yet be able to challenge the creative authority of Paris, they were "as good as anyone at putting on a 'show.'"[13] Several important postwar fashion shows strategically emphasized the connections between Italian fashion and Italy's heritage of art and culture. At one show, held in Milan in 1949, the couturier Germana Marucelli presented dresses inspired by Renaissance art. At another, even more famous fashion show in May 1950 at the Teatro della Pergola in Florence, mannequins emerged from reproductions of famous Renaissance paintings.

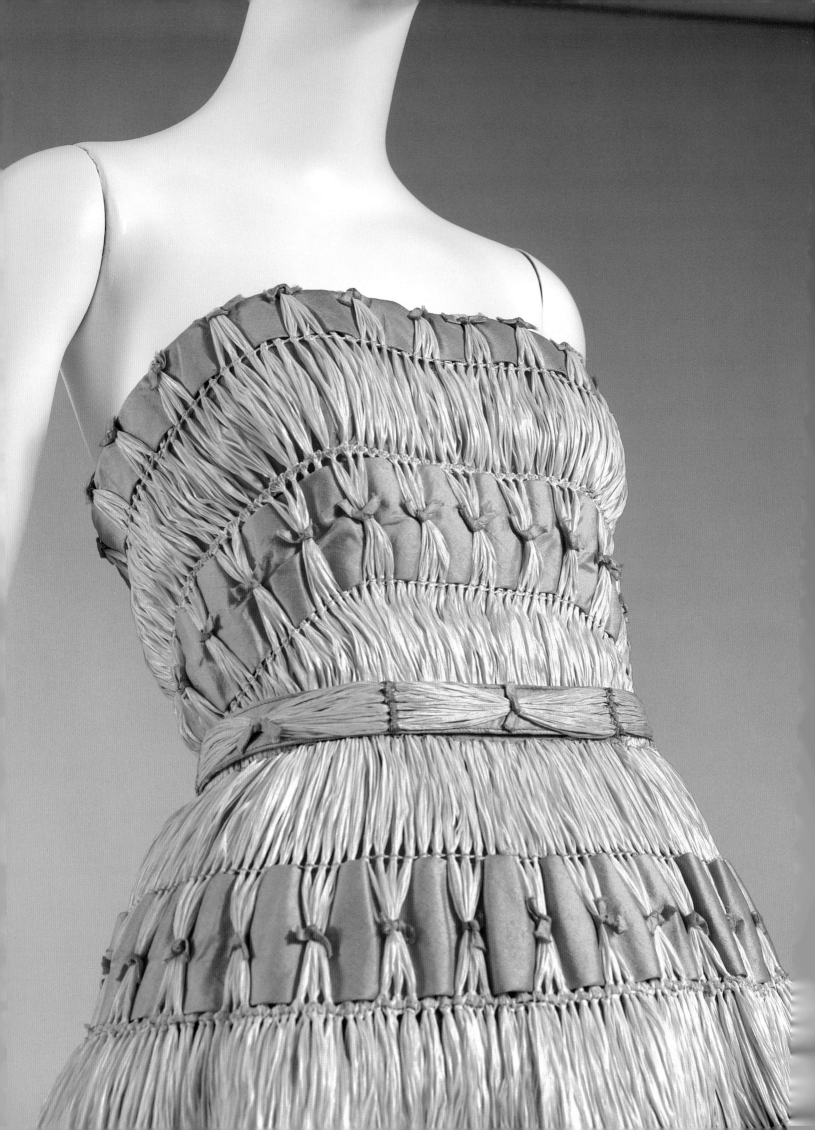

The "Birth" of Italian Fashion
at the Sala Bianca in Florence

The commercial "invention" of Italian fashion is usually credited to Giovan Battista Giorgini, who organized a fashion show on 12 February 1951 at his residence at the Villa Torrigiani in Florence. A businessman, Giorgini had considerable experience in selecting Italian-made products for American department stores, and he decided to showcase the designs of a few Italian firms. Featured were the Roman couturiers Maria Antonelli, Carosa (Princess Giovanna Caracciolo), Alberto Fabiani, the Fontana Sisters, Emilio Schuberth, and Contessa Simonetta Visconti, along with Jole Veneziani, Marucelli, Noberasco, and Wanna from Milan, and four designers in the boutique sector: Emilio Pucci, Baroness Gallotti (known as "the weaver of Capri"), Avolio, and Bertoli. Together they showed 180 creations.

Only eight American department store buyers and one journalist attended the fashion show, but the trade publication *Women's Wear Daily* published a front-page article: "Italian Styles Gain Approval of U.S. Buyers." When Giorgini organized another big fashion show in July 1951, featuring designers from Rome, Milan, Turin, and Florence, almost two hundred American buyers and journalists attended the event at the Grand Hotel in Florence, along with another hundred from Italy and elsewhere in Europe. Afterwards a grand ball was held at which important guests from around the world were asked to wear garments of pure Italian inspiration.

Soon afterwards *Life* published a major article entitled "Italy Gets Dressed Up," which reported rhapsodically on how Italy's "amazing postwar recovery" had resulted in the development of a "fledgling fashion industry" that attracted American buyers and was even said to "pose a challenge to Paris." American fashion leaders were said to have "descended on the little museum city of Florence," like a "friendly invasion." The fashion show was crowded and disorganized, "but the eager-to-please Italians" did their best and ended by "scoring" a real success. According to the American journalist, "Italy . . . made a good beginning in its upstart attempt to enter fashion's big leagues."[14] The French press warned that "the bomb" exploding in Florence menaced the "monopoly" of the Parisian haute couture.[15]

The next "Italian High Fashion Show" was held in July 1952 at one of Florence's most beautiful settings, the Sala Bianca of the Palazzo Pitti. This event is widely regarded as the "birth" of Italian fashion. Nine high fashion houses participated, along with sixteen houses presenting sportswear and boutique styles. The nineteen-year-old Roman couturier Roberto Capucci made his debut. As the press observed, "The white and crystal splendour of the Pitti Palace" provided an appropriately impressive setting for Italy's fashion shows. Florence quickly became a regular venue for fashion shows, and the Pitti Palace was regularly "jam-ful for buyers and the press for the Italian Collections."[16]

Even Francophiles like the American fashion editor Bettina Ballard succumbed to the charm of Italian fashion, "because it was so manifestly attractive to discover fashion in a country so full of treasures to see and eat, and people who were so polite and open-armed."[17] In addition to the fashion shows, there were glamorous social events. Fashion buyers and journalists were delighted to mingle with Italian aristocrats at grand balls held in historic settings. Unfortunately, no sooner had Florence emerged as the center of Italian fashion than eight Roman designers defected from the fashion show at the Sala Bianca, preferring to show their clothes two days earlier in Rome. "Civil war has broken out in Italian fashion," reported *La Nazione*.[18]

Ultimately, a compromise was worked out, whereby Florence showed accessories and boutique fashions, while Rome became the center of the couture or *alta moda*. Meanwhile, Italian designers began to tour America, organizing fashion shows at department stores and social events (including parties at the Italian embassy) and even on American television shows. By the end of the 1950s, Italian fashion was being exported in significant quantities to the American market, where there was considerable enthusiasm for the casual elegance associated with Italian style.

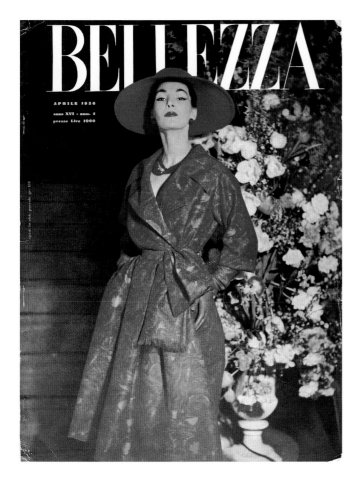

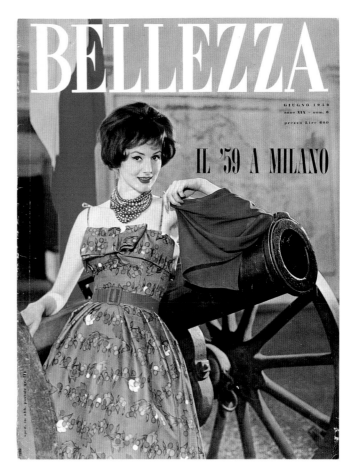

IL '59 A MILANO

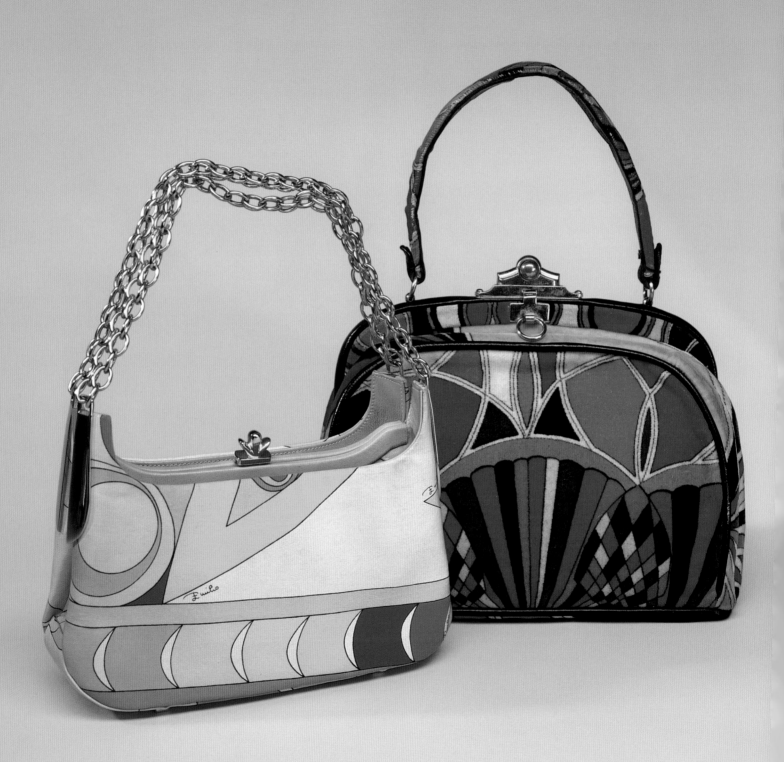

Italy Changes the Way the World Looks

facing page

EMILIO PUCCI
Evening bag in white silk
faille printed in yellow and
fuchsia with gold metal
chain handle, 1967–68. The
Museum at The Fashion
Institute of
Technology, Gift of
Mr. Jeffery Beuglet, 91.14.5.
Box bag in polychrome
printed velveteen with gold
metal handle and clasp,
1968. The Museum at The
Fashion Institute of
Technology, Gift of
Ms. Helen Ziegler, 86.30.6.
Photograph by
Irving Solero

"Just Like the Chianti, Italy's fashions are becoming as well known as its table wine," reported *Life* in 1952, adding that Italian fashion was no longer seen primarily "in terms of handbags and umbrellas."[19] The comparison is telling. If the French haute couture was still the fashion equivalent of a fine bottle of Chateau Margaux, then Italian fashion was young and fun, relatively inexpensive but also sophisticated and European. Like Italian design in general, from Vespa motorscooters to Olivetti typewriters, Italian fashion was characterized by a "pared-down, modern look." However, as Nicola White astutely observes, "the reputation of Italian fashion was [also] firmly rooted in high quality and traditional associations; casual sportswear became casual elegance."[20]

Italian designers excelled in casual, but elegant, sportswear separates, which suited a postwar lifestyle that was less formal, less stratified by class, and more international. "There are three exciting things about Italian fashion today," declared American *Vogue* in 1952:

> The first is that Italy is capable of producing a kind of clothes which suit America exactly . . . Namely: clothes for outdoors, for resorts . . . [and] separates, fads . . . all the gay things, all the boutique articles and accessories.

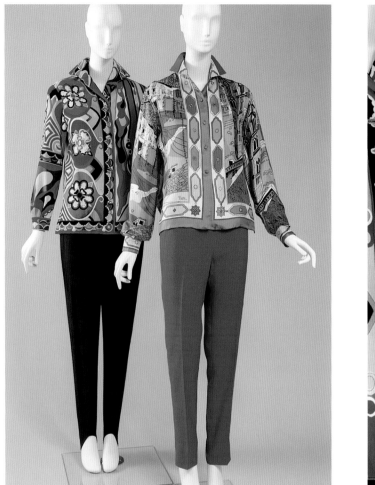

The second is the fabrics – anything and everything pertaining to Italian fabrics is newsworthy.

The third is the evening dresses, marvellously made in marvellous silks at a relatively low cost. (Evening life is something that the Italians understand thoroughly . . .)

These are the three things in which the Italians need to be encouraged; they should be given wings to develop their native specialties, and urgently discouraged from French adaptations.[21]

Despite a somewhat patronizing tone, this analysis was accurate. Italian textiles were consistently outstanding. The quality of Italian products was high, and the cost relatively low. And Italian designers were indeed strong in sportswear separates, such as capri pants and knitwear, as well as accessories.

Almost a decade later, in 1961, *Life* celebrated "The Bold Italian Look that Changed Fashion." The past ten years had been a "Dramatic Decade," full of "Knockout Clothes," declared the American journalist, adding that Italy had achieved great things in all areas of design, not only fashion: "Italy in a few brief years has

EMILIO PUCCI
Printed silk blouse with fall tone design of Italian piazza with coordinating red silk pants, c. 1955.
The Museum at the Fashion Institute of Technology, Gift of Lauren Bacall, 74.107.47 and 71.254.57. Shirt-jacket in printed velveteen with abstract design and coordinating black stretch pants, c. 1965.
The Museum at the Fashion Institute of Technology, Gift of Elaine. A. Flug. 83.212.2.
Photograph by Irving Solero

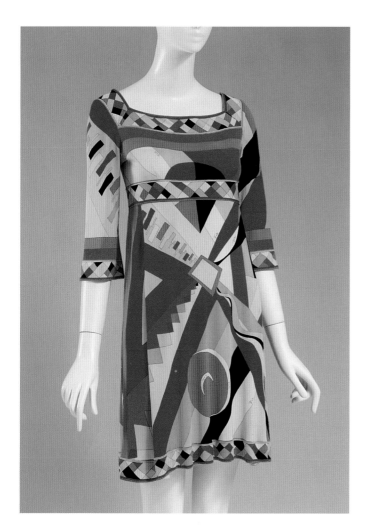

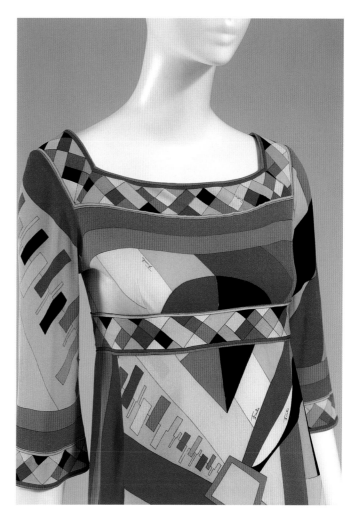

changed the way the world looks – the cars, buildings, furniture and, most universally, the women." The Italian collections were now a major stop on the fashion circuit; Italy exported more clothes than any other country. "But Italy's fantastic fashion record does not rest on volume alone. Her designers have contributed an outstanding list of style changes," including "the most striking color combinations, the tightest pants, [and] the wildest prints."[22]

The success of Emilio Pucci, one of the first international stars of Italian fashion, was inseparable from his kaleidoscopic textile designs, which were made up into scarves, shirts, and other separates. A Pucci scarf might be printed in more than a dozen colors, in a swirling abstract design. He also paired capri pants with silk shirts in bold scarf-print designs, helping to establish one of the classic styles of the twentieth century. Like many Italian designers of this period, Pucci was an aristocrat, whose *palazzo* in Florence was an impressive Renaissance structure. He entered the fashion business almost by accident, when a ski outfit he had designed was featured

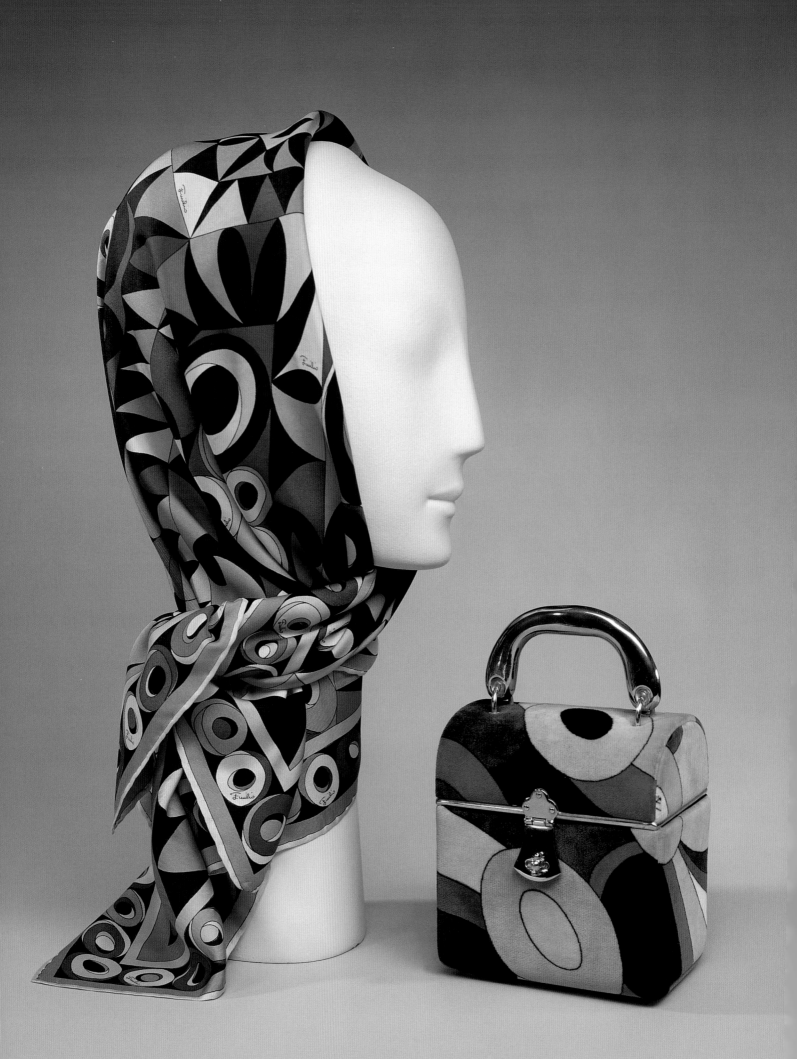

in *Harper's Bazaar* in 1948. After the show at the Sala Bianca in 1952, he began collaborating with all of the big American department stores, visiting America often.

Throughout the 1950s and 1960s, Pucci's brightly colored "featherweight" silk jersey separates were symbols of the international "jet set." He also experimented with synthetic materials, such as Emilioform (a mixture of silk and nylon), and with stretch fabrics. The better to minimize weight and volume, he eliminated linings and paddings from his clothes. An opponent of the restrictive girdle and underwire brassiere, Pucci developed soft, unstructured undergarments – made also in his signature prints. In its liberation of the body, Italian fashion was in the forefront of cultural developments. Flaunting bare feet and legs in sandals and no stockings, and wearing dresses without girdles or underwire brassieres, Italians were pioneering easy, comfortable, body-conscious clothing. Simplicity and comfort were central to mass-produced American sportswear, but Italy provided sportswear with greater sophistication and cultural cachet.

facing page

EMILIO PUCCI
Printed silk scarf in brown, grey, black, and white engineered abstract design, c. 1975. The Museum at The Fashion Institute of Technology, Gift of Dorothy Small. Square box bag in pink, navy, turquoise and green printed cotton velveteen, c. 1969. The Museum at The Fashion Institute of Technology, Gift of Ms. Yvonne Dunleavy, 91.233.2. Photograph by Irving Solero

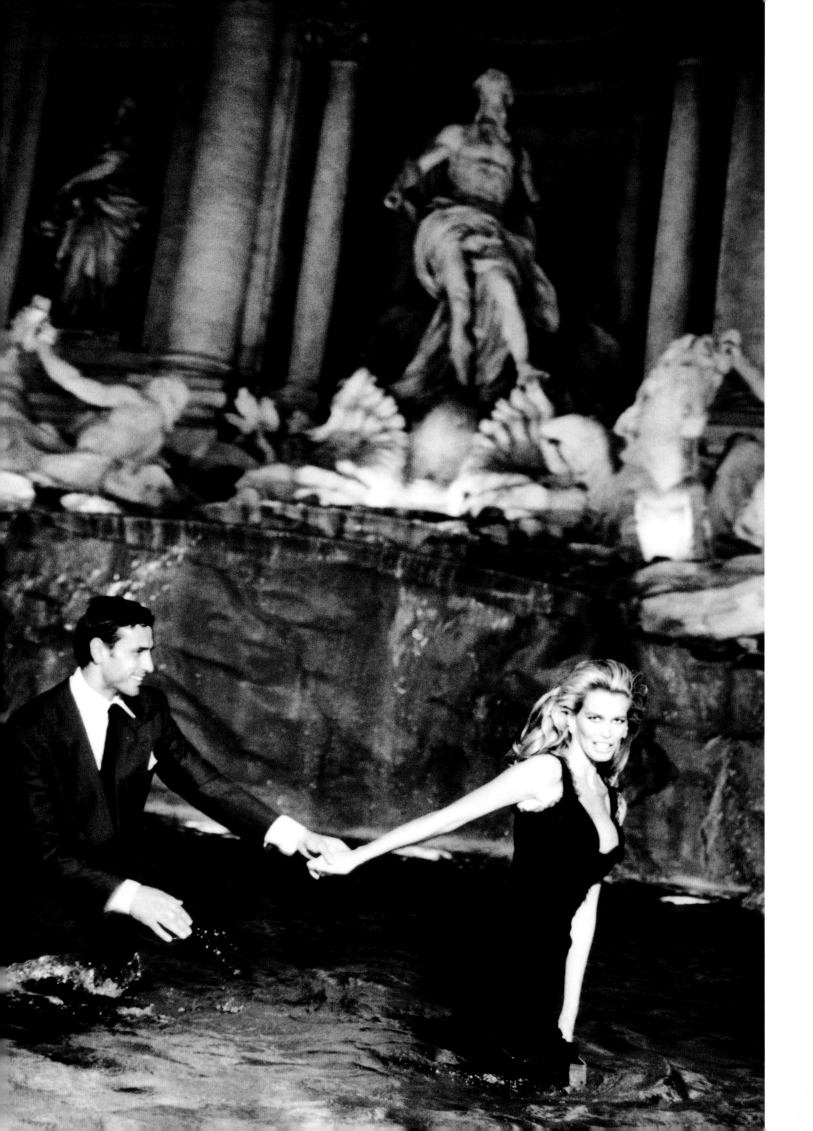

La Dolce Vita, or Rome Triumphant

Italy offered also Hollywood-style glamour, with the prestige of a European label. The marriage of fashion and film was crucial to the success of the Roman couture. Rome was Hollywood on the Tiber, center of the Italian film industry and also the place where many American films were made. Italian and foreign film stars formed a major clientele for the Roman couture. Not only did individual actresses patronize Roman couturiers, but the studios also employed them to make film wardrobes. The existence in Rome of a complicated and highly social upper class was also relevant, since the scions of noble houses formed yet another group of couture clients. As a result, many couture houses flourished. Emilio Schuberth, for example, was born in Naples in 1904 and opened a couture house in Rome in 1938. Among the clients who appreciated Schuberth's glamorous dresses were Gina Lollobrigida and Sophia Loren.

Even more famous were the Fontana Sisters – Zoe, Micol, and Giovanna – daughters of a dressmaker who opened their couture house in Rome in 1944. "We could still hear the bombs going off on the beaches when we moved into our first atelier in Rome," recalled Micol Fontana many years later. "But that didn't matter. It was our dream to own an atelier."[23] The Fontana Sisters created luxurious, dramatic dresses, often with lavish decoration. They were especially famous for their evening gowns, film costumes, and wedding dresses. By 1948, Hollywood stars such as Loretta Young and Myrna Loy were already being photographed wearing Fontana evening dresses. The Fontanas received even more publicity in 1949 when Linda Christian wore a

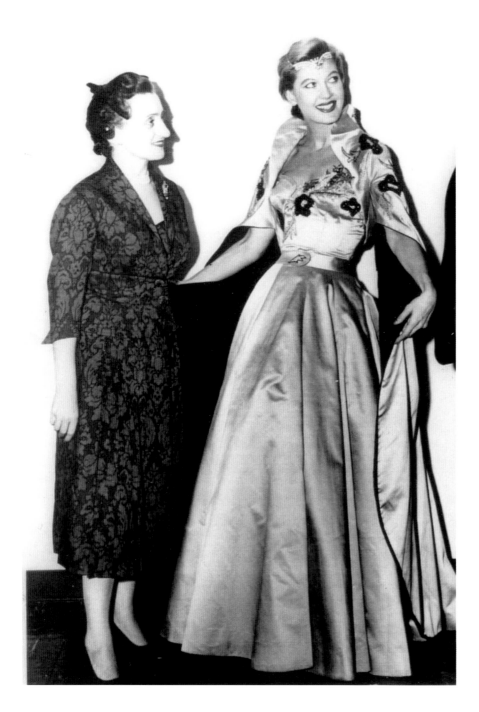

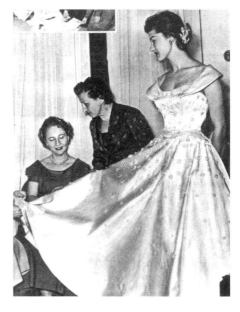

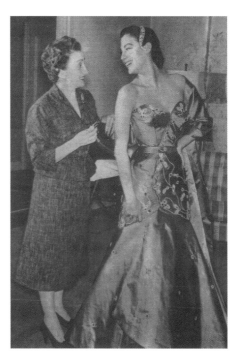

Fontana wedding dress for her marriage to Tyrone Power, while the couple were in Rome filming *Prince of the Foxes*. Ava Gardner wore dresses by the Fontana Sisters in the 1953 film, *The Barefoot Contessa*, and in 1956 President Truman's daughter, Margaret, wore a Fontana Sisters wedding dress. Other film stars who wore Fontana dresses included Audrey Hepburn, Elizabeth Taylor, and Kim Novak. One of the Fontanas' most famous designs was the black silk-wool "cassock dress" designed for Ava Gardner in 1956, as part of the Fontanas' "Cardinale" collection, which was inspired by ecclesiastical dress. This controversial design later served as the inspiration for one of the dresses worn by Anita Ekberg in Fellini's *La Dolce Vita*.

Not all Roman couturiers were associated with film, however. Roberto Capucci emerged early as one of the most extraordinary artists of the Roman couture. Born in 1930, he opened his own atelier in 1950, and in 1952, *Vogue* described him as "easily Rome's most promising young designer." His clothes might sometimes be "too costume-y," wrote the American journalist, but they "are completely original and full of ideas."[24] Highly gifted and imaginative, Capucci was – and remains – a true architect of fashion. "In my continuing search for beauty and purity, I concentrate initially on the basic form," he says. "During this phase I do not want to be influenced by outside factors, and I think in black and white. Next comes color in all its intensity . . ."[25] Indeed, Capucci became almost as well known for his dazzling colors as for his extraordinary silhouettes. Uninterested in trends, he has always focused on artistic expression, pleating and manipulating fabric into fluid, sculptural forms.

Contessa Simonetta Visconti, referred to in America as the "Titled Glamour Girl of Italian Designers,"[26] was born in 1922, the daughter of Duke Giovanni Colonna; she married Count Galeazzo Visconti di Modrone, and used her married name, Simonetta Visconti, when she began designing clothes in 1946. Her marriage to Count Visconti was terminated in 1949, but press reports continued to alternate between her paternal and marital titles for several years. Described as the "youngest, liveliest member" of the Italian fashion world, the "petite and coquettish" Simonetta was best known for her young, ultra-feminine cocktail dresses.[27] Also popular were her sports clothes, and *Life* reported happily that Simonetta enjoyed vacationing in America and had "an affinity for American style."[28] In addition to her couture dresses, Simonetta, like the Fontana Sisters, also produced high-quality ready-to-wear, which was usually referred to in the press as "boutique" fashion. Her use of materials was imaginative, and her clients included the fashion editors Bettina Ballard and Carmel Snow.

In 1953, Simonetta married Alberto Fabiani, another well-known Roman fashion designer. After their marriage, they maintained separate, rival establishments in Rome. "My husband is known for his style and I for mine," she said. Whereas Simonetta favored feminine dresses, Fabiani was described as "the surgeon of suits and coats."[29]

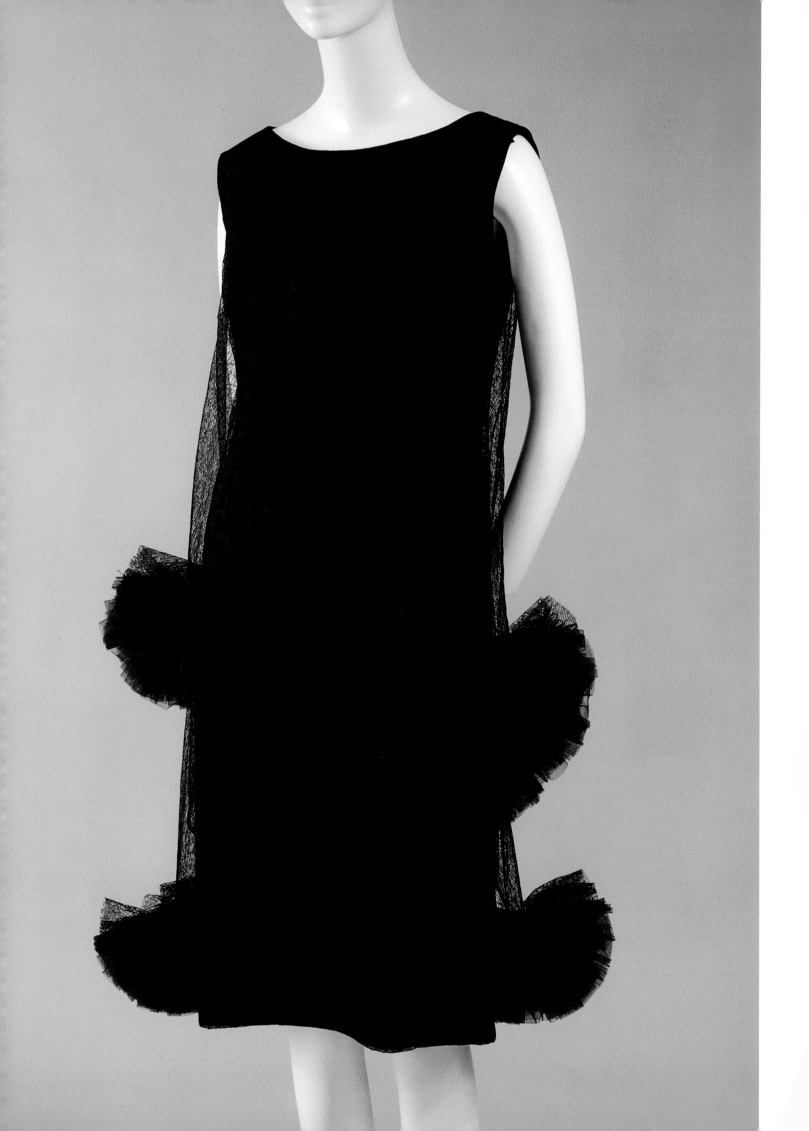

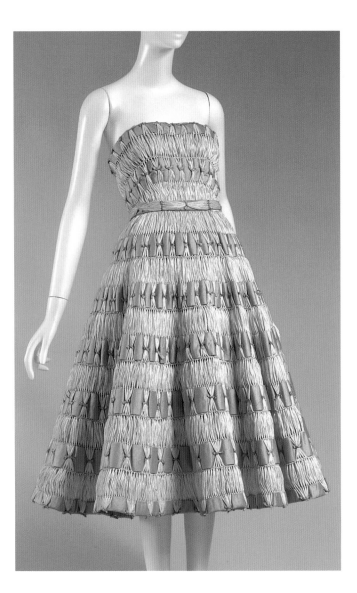

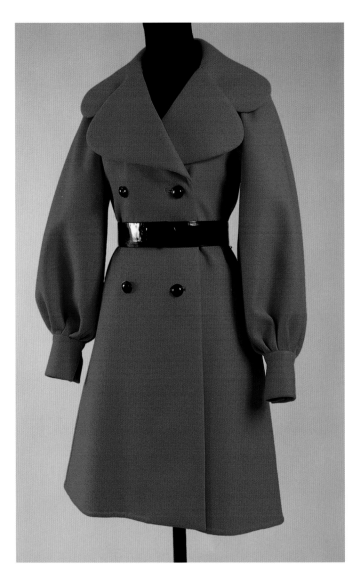

SIMONETTA
Strapless dress in off-white synthetic raffia and pink silk taffeta with matching belt, c. 1953. The Museum at The Fashion Institute of Technology, Gift of Ms. Jacqueline Slifka, 77.228.1.
Photograph by Irving Solero

ALBERTO FABIANI
Double-breasted coat in red wool crepe with black plastic buttons and patent leather belt, 1972. The Museum at The Fashion Institute of Technology, Gift of Mr. David Zelinka, 73.34.1.
Photograph by Irving Solero

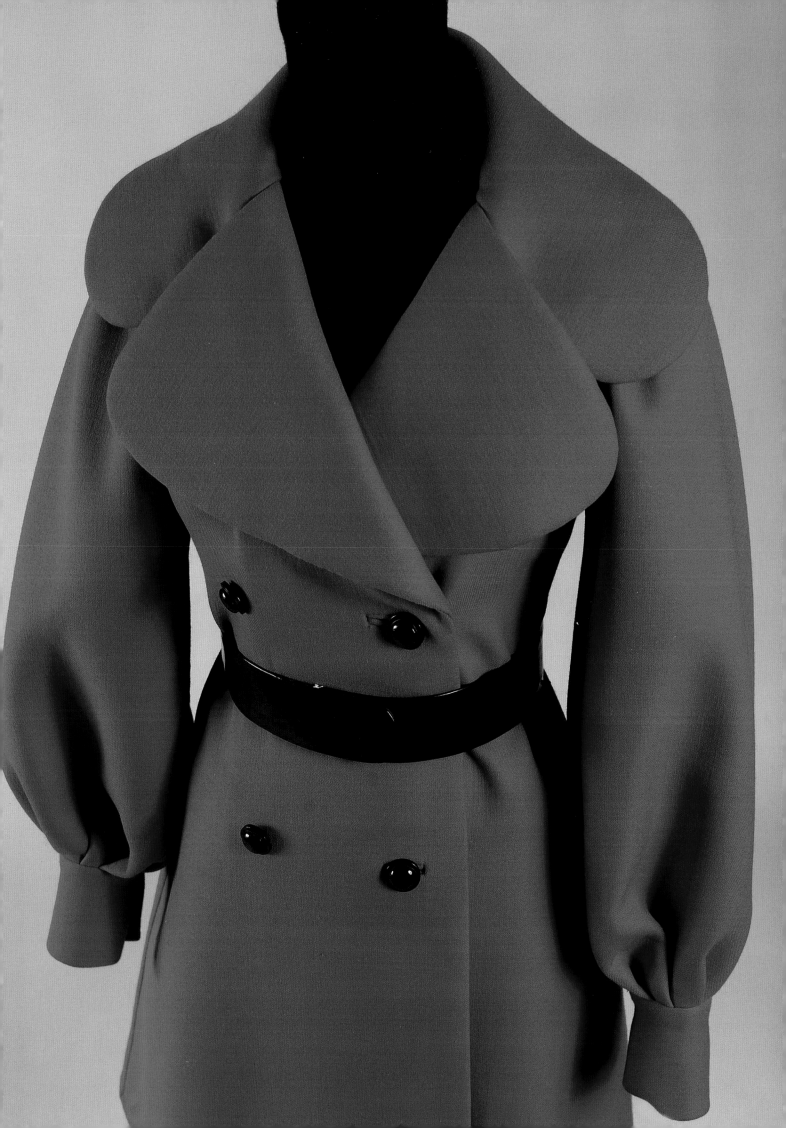

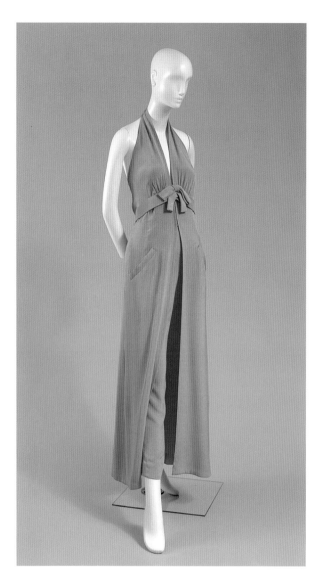

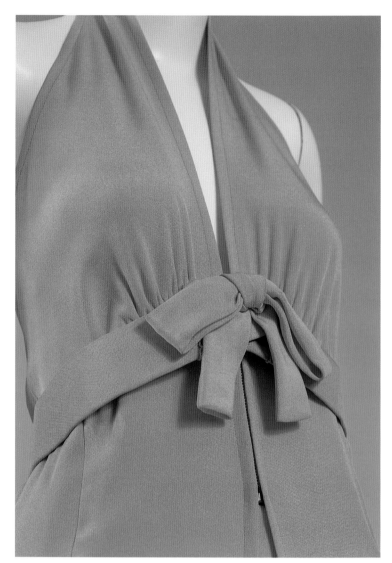

"An acknowledged master," he was known for his "superlative – elegant and aristocratic" tailoring.[30] Among the first to defect from Florence to Rome, in 1962 the couple moved to Paris. "Bonjour Paris, Adio Rome," reported *Women's Wear Daily*. "The mother and father of Italian fashion, Simonetta and Fabiani, are off to Paris . . . a real blow to the Italian couture."[31] The transplant was unsuccessful (Fabiani returned to Rome, while Simonetta abandoned fashion altogether), but the Roman couture survived.

In a world transformed by youth culture, Rome remained an oasis of high style. The international jet set included many members of Italian high society, such as Princess Irene Galitzine, who became famous for what the fashion editor Diana Vreeland dubbed her "palazzo pyjamas." Hailed by *Women's Wear Daily* in 1966 as a

GALITZINE
Orange silk crepe palazzo pajamas, halter top, divided skirt and belt, 1968. The Museum at The Fashion Institute of Technology, Gift of Vera Gawansky, 78.46.1. Photo by Irving Solero

FEDERICO FORQUET
Coat in orange double-
faced wool printed with
red and black squares,
c. 1955. The Museum at
The Fashion Institute of
Technology, Gift of
Diana Vreeland, 79.147.12.
Photograph by
Irving Solero

"Leader of the Italian Couture," Frederico Forquet was another one of the Beautiful
People who worked as a couturier, creating some extraordinarily beautiful garments.[32]
His clients included Diana Vreeland and socialite "Baby Jane" Holzer.

The single most important and successful designer to emerge in Rome during the
1960s was Valentino. Described once as looking like a Roman emperor, Valentino
Garavani studied at the Chambre Syndicale de la Couture in Paris before opening his
own couture house in Rome in 1960. Over the following four decades, he moved
from one success to another, including ready-to-wear, menswear, fur, and fragrances,
but the foundation of his style remains the couture tradition of luxury, quality, and
extravagance. His White Collection of 1968 created a sensation. Yet his signature color
is a brilliant shade of red – Valentino red – which appears in every collection. He

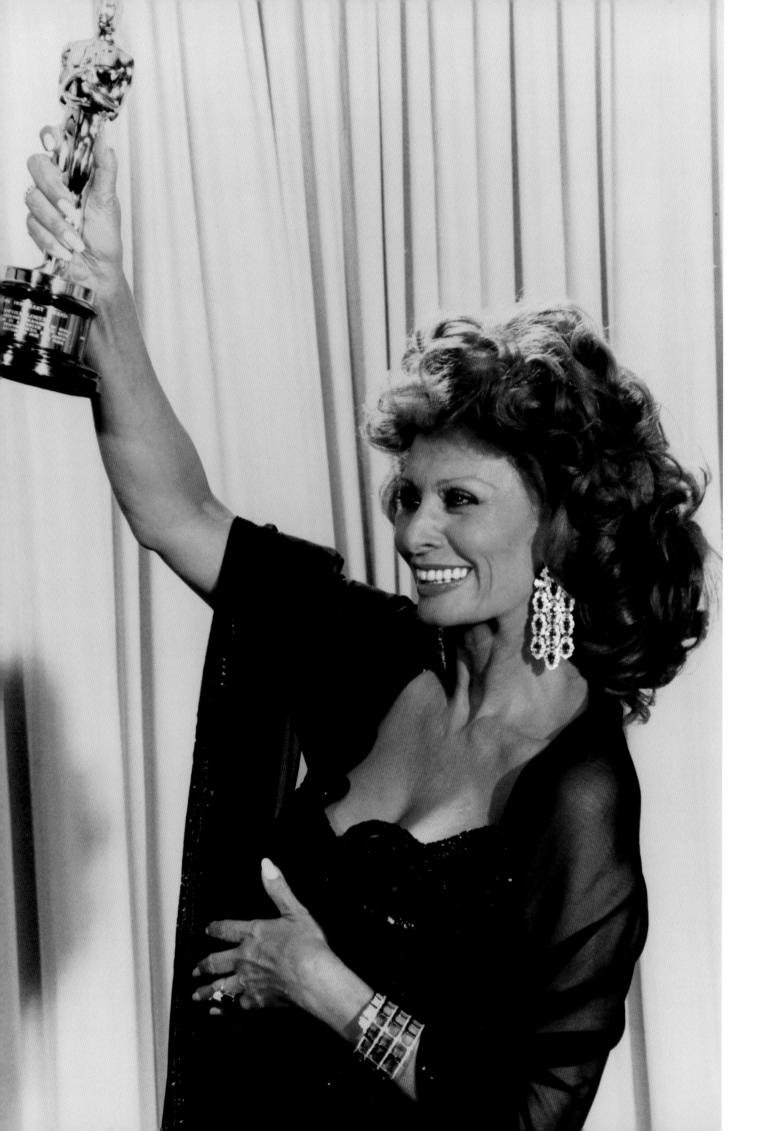

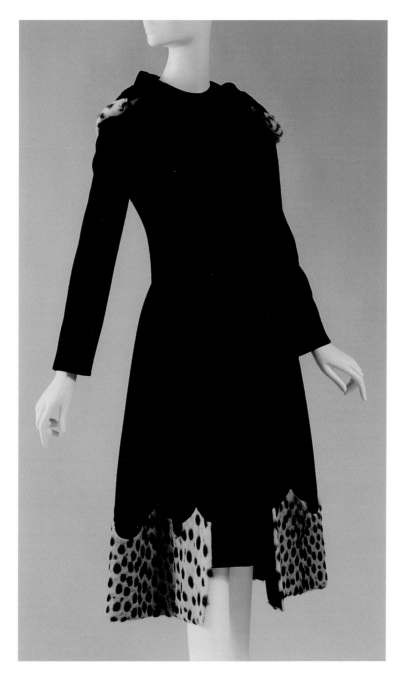

is also known for his extravagant combinations of textures and patterns, for his sumptuous applied decoration, and sophisticated sense of proportion.

Throughout his long career, Valentino has dressed many celebrities, from Sophia Loren to Gwyneth Paltrow. But perhaps his most famous client was Jacqueline Kennedy, who chose to wear a lace-trimmed Valentino dress for her marriage to Aristotle Onassis. Refined yet opulent, Valentino's clothes continue to attract an international clientele who share his style of life.

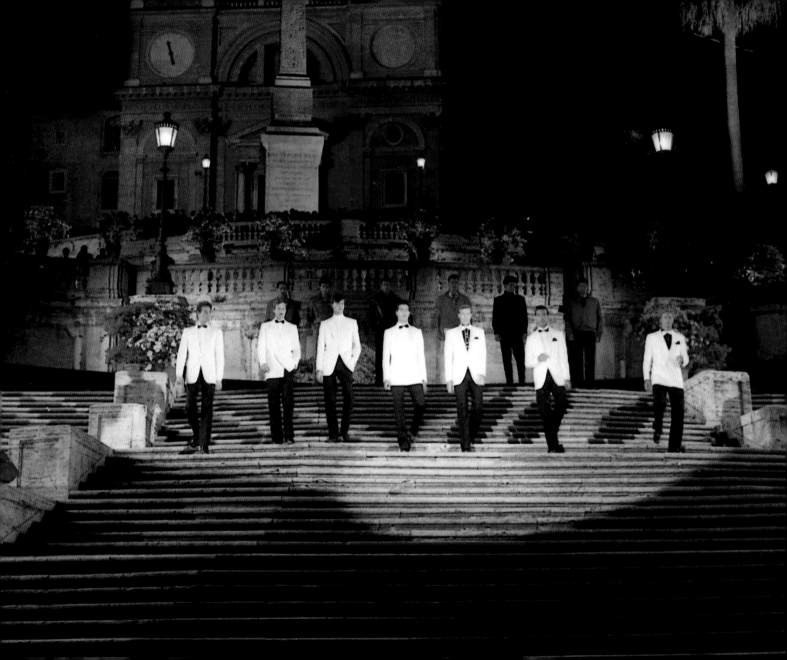

The Continental Look

Just as Italian styles provided an alternative to French fashion, so also did the "Continental Look" of the 1950s threaten the traditional dominance of London's Savile Row. In 1956, *Vogue* observed that "Italian influence on men's clothes is a fact now – and American men are getting to know the facts: that Italian tailoring can be very much at home in America; that naturally slender jackets and straight-hanging cuffless trousers . . . are smart and comfortable at the same time."[33] Since American men were unaccustomed to stylish, body-conscious clothes, the press sometimes felt constrained to reassure readers that, while the Italian man "dresses up to present a *bella figura*," he was also endowed with a "triumphant masculinity" and remained a "he-man."[34]

Among the many excellent Italian tailoring establishments, Brioni was perhaps the best-known internationally. Based in Rome, Brioni often showed together with the Fontana Sisters. Just as actresses favored gowns by Fontana or Schuberth, so also did Hollywood stars such as Cary Grant wear Brioni suits. The Brioni suit was characterized by a slim silhouette, a softened structure, and the heretical introduction of raw silk and even color into the hitherto staid world of classic men's tailoring. Clean and modern in its lines, Brioni menswear was also characterized by exceptionally tactile and luxurious tailoring.

In addition to tailored suits and jackets, Italy was known for high-quality men's shirts and sweaters. The Duke of Windsor, for example, wore hand-made Italian shirts.

BRIONI
Piazza di Spagna, Rome,
1985. Courtesy of Brioni

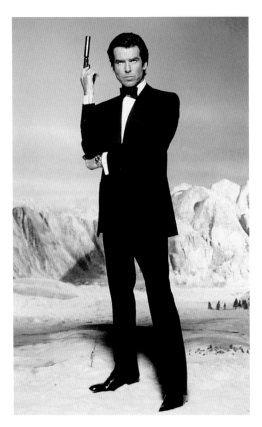

Traditionally, the wealthy had their shirts made by personal tailors, while poor men relied on the sewing skills of female relatives. There was only a limited market for the industrialized garment producer. In 1920, however, the Lorenzini family built a factory in Brianza, outside Milan, for the manufacture of men's shirts. By the 1960s, the company really began to blossom, by focusing on a strategy that combined the most advanced technology with old-world craftsmanship. The knitwear company Avon Celli also began in the 1920s, when Pasquale Celli knitted a collar onto a Henley undershirt, creating a three-button polo shirt. Avon Celli knitwear was first imported into the United States in 1957, attracting clients such as Gary Cooper, Clark Gable, and Katharine Hepburn. Today Avon Celli utilizes state-of-the-art computers and also the original early twentieth-century, fine-gauge heritage looms which are painstakingly maintained because they are capable of knitting to an incredible 36-gauge standard, unsurpassed for making fully fashioned knitwear.

Pierce Brosnan as James Bond, wearing Brioni. Courtesy of Brioni

In her essay "Stylism in Men's Fashion," Chiara Giannelli Buss argues that, "The concept of 'made in Italy,' hitherto the guarantee of fine materials, excellent workmanship and *good taste* [was replaced in the 1970s] with that of the 'Italian look,' the status symbol of a new economic power, conscious of the social implications of fashion and with a decidedly international character."[35] This statement is insightful, although, of course, fine materials, excellent workmanship, and even good taste still played a crucial role in Italian menswear. It is important to stress, however, that even before designers such as Giorgio Armani helped launch the "Italian Look" of the 1970s and 1980s, there was already coming into being a modern Italian style of menswear.

Young men were especially attracted to the Italian style. Colin MacInnes's 1959 novel of English youth, *Absolute Beginners*, emphasized the importance of Italian style: "neat white Italian round-collared shirt, short Roman jacket very tailored (two little vents, three buttons), no turn-up narrow trousers with seventeen-inch bottoms absolute maximum, [and] pointed toe shoes." By about 1963, "swinging" London had become the international capital of youth fashions for both men and women.

www.avoncelli.com

AVON CELLI
24-ply 'large Macaroni'
hand-knit sweater for men
and women. Courtesy of
Avon Celli

London's mod fashions (the term was an abbreviation of "modern") were heavily
influenced by Italian style and flair. Looking back on his youth, the pop star David
Bowie has recalled, "I liked the Italian stuff, the box jackets and the mohair."[36]

In the 1960s and 1970s an international fashion revolution, which was closely
associated with the rise of youth culture, took place. Identified first with "swinging"
London, youth styles were then appropriated by French designers, such as Courrèges,
Cardin, and Saint Laurent. But Italian tailors working in London had played a role
in the mod style from its inception. Designers in Italy were also involved in these
developments. In 1968, for example, Antonio Cerruti was quoted in *Fortune*,
explaining why he was moving his textile company into the new field of men's
fashionable clothing. "I'm playing entirely this card of fashion," Cerruti said. "Fashion
is a novelty for men today – it could revolutionize my business."[37]

New Directions in Italian Fashion

"If the Italian clothes designers would pull together, they could probably match the French . . . Instead they are too busy sticking pins into each other," complained *Newsweek*. The competition between Florence and Rome did not work to Italy's advantage, since foreign buyers and fashion reporters "were forced either to take sides in the battle or split up into two teams to cover both cities because of openings that conflicted."[38] Ultimately, this division helped to provide an opportunity for Milan.

There were already designers working in and near Milan. Mila Schön, for example, opened her own small atelier in Milan in 1959, and during the 1960s, she won acclaim for her crisp, double-faced wool ensembles, which were executed with faultless attention to detail. However, although Schön's fashions were directional in design, they continued to be aimed at an elite clientele. Biki was another respected Milanese designer, whose clients included Maria Callas.

Meanwhile in Venice, Giuliana Camerino began her career with the production of handmade bags. She soon became famous under the name Roberta di Camerino. The printed *trompe l'oeil* that characterized her handbags and other accessories, such as scarves and umbrellas, was then applied to clothing. In the 1960s, she began designing extraordinary *tromp l'oeil* dresses, which, together with her handbags, were distributed through a network of luxury boutiques.

The boutique provided a potential alternative to the traditional division between couture (high fashion) and mass fashion. Especially influencial was Elio Fiorucci,

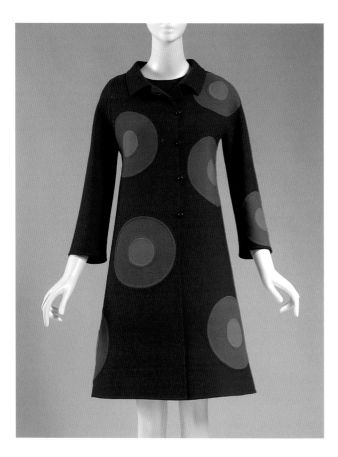

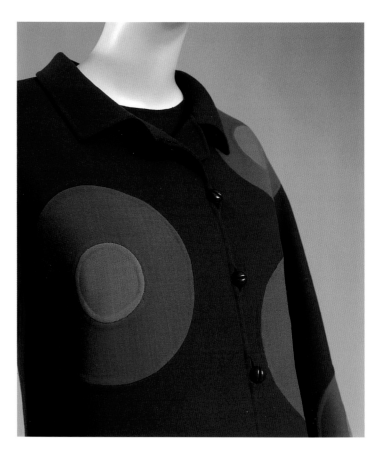

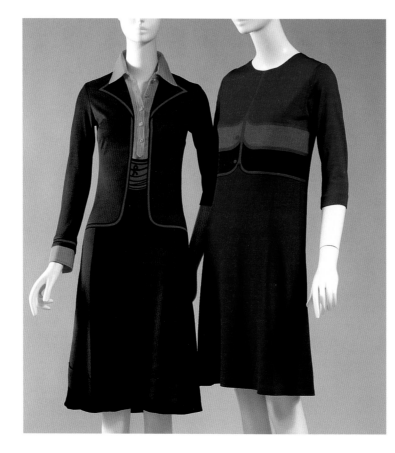

above left and right

MILA SCHÖN
Coat and matching skirt in turquoise blue double-faced wool with light blue circular insets, c. 1968. The Museum at The Fashion Institute of Technology, Gift of Mrs. Donald Elliman, 78.208.1. Photograph by Irving Solero

left and facing page

ROBERTA DI CAMERINO
Dress in grey knit with pink collar and cuffs, 1973–74. The Museum at The Fashion Institute of Technology, Gift in Memory of Susan Engel Levy, 2002.67.1. Wool jersey chemise dress with engineered print, 1968–69. The Museum at the Fashion Institute of Technology, Gift of Eleanor Sims, 94.139.1. Photograph by Irving Solero

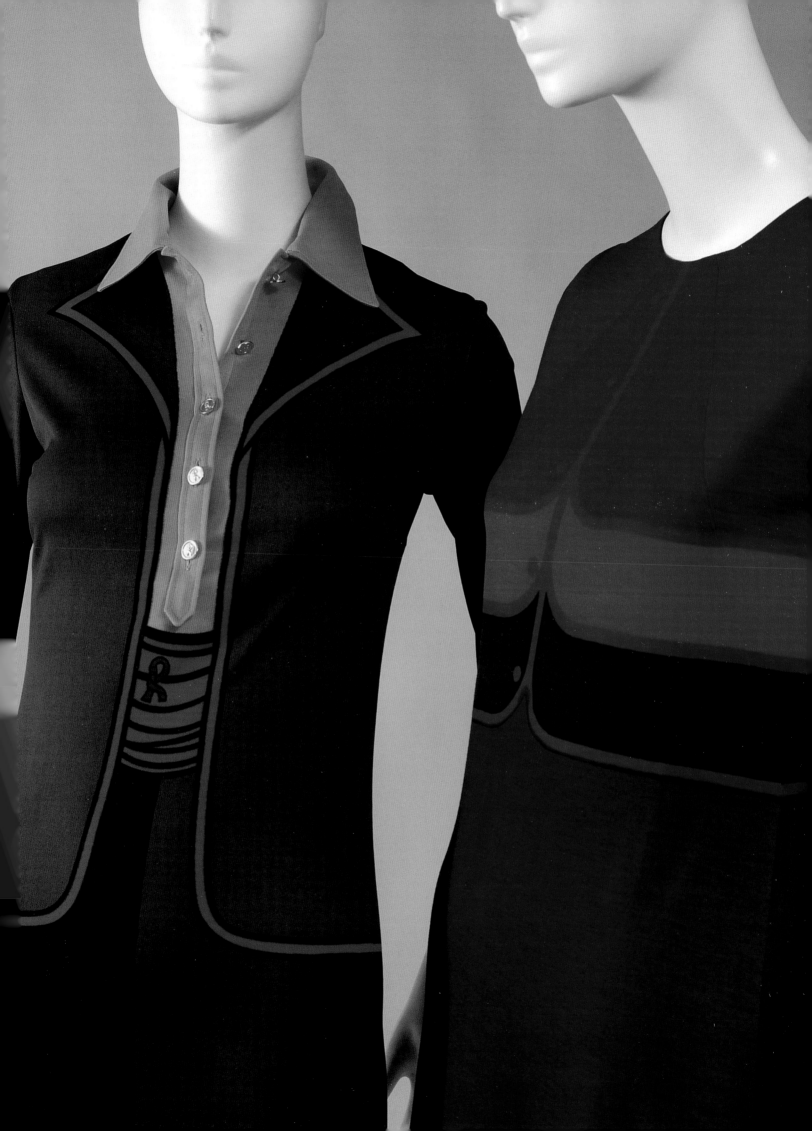

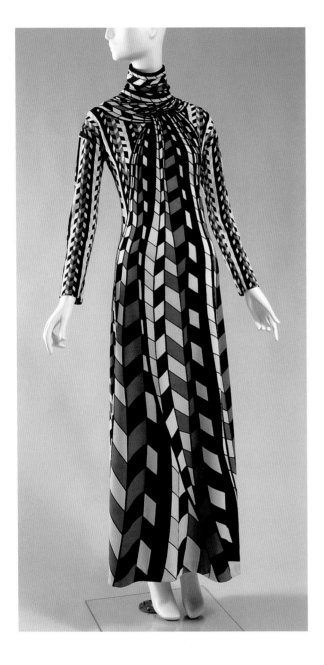

ROBERTA DI CAMERINO
Evening dress in grey, white, and black jersey, 1976/77.
The Museum at The Fashion Institute of Technology,
Gift In Memory of Susan Engel Levy, 2002.67.1.
Photograph by Irving Solero

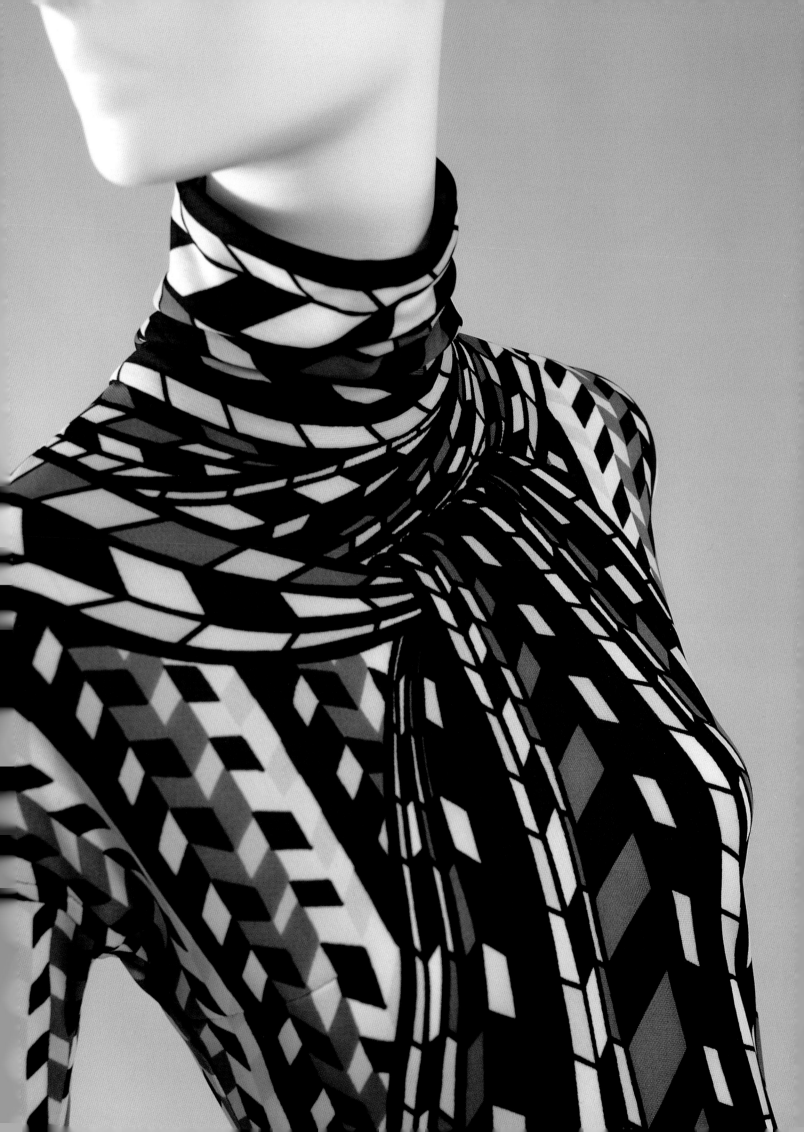

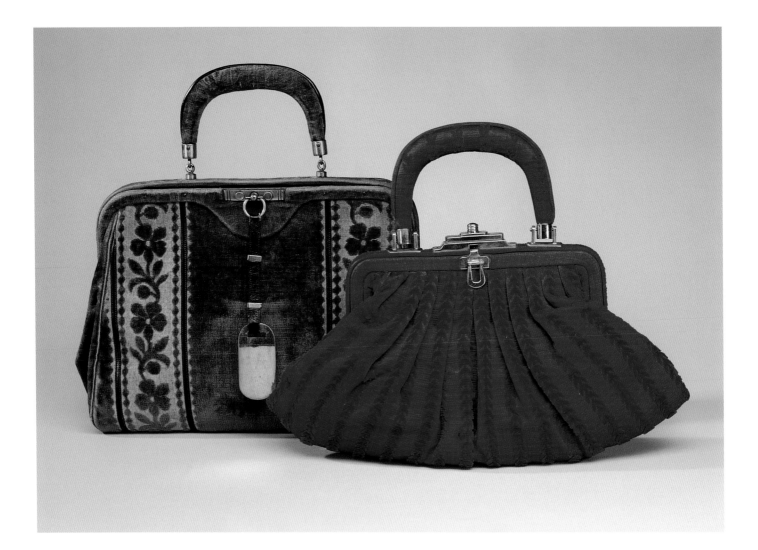

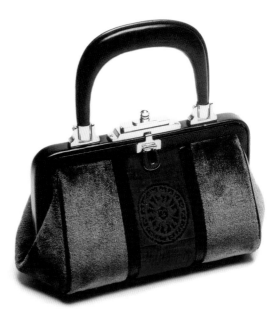

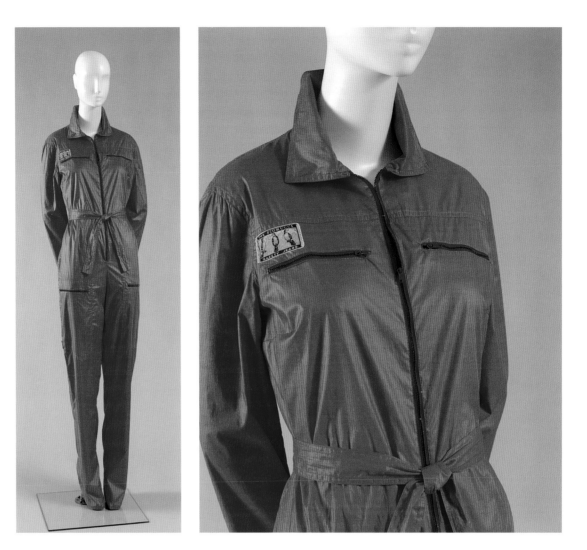

who opened his first boutique in Milan in 1967. Initially, he imported youth fashions from sites such as Carnaby Street, with the exception of his own shoes and other accessories. Soon, however, he was also producing inexpensive, colorful youth fashions, which achieved an international reputation.

One of the landmark enterprises of modern Italian fashion, Missoni knitwear was an inspired combination of art and industry. A family-owned company, like many in Italy, it was founded in 1953 in Trieste by Ottavio (Tai) and Rosita Missoni. By 1961 the company had pioneered new mixtures of materials and colors, and began to develop its signature patterns, mixing straight, zig-zag, and wavy stripes. As the fashion historian Richard Martin once observed: "Missoni brought a vivid sense of imagination to knits, rescuing them from the . . . old-fashioned aspects of handknits and from the conventional sameness of many machine-knitted products. Like many Italian products of the postwar period, the value of the product was . . . in the unquestionable supremacy of design attained through machine."[39]

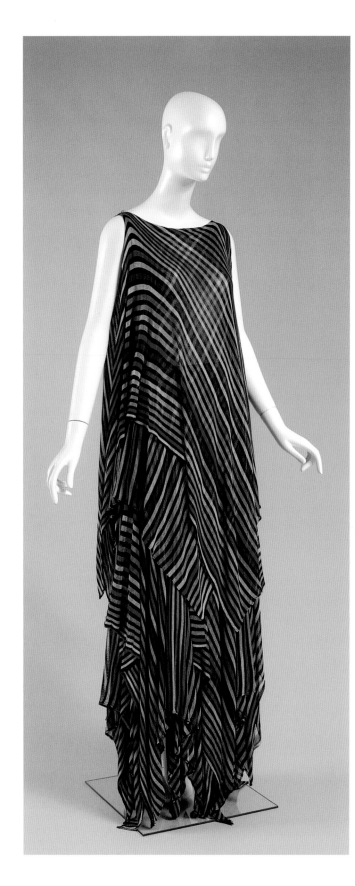

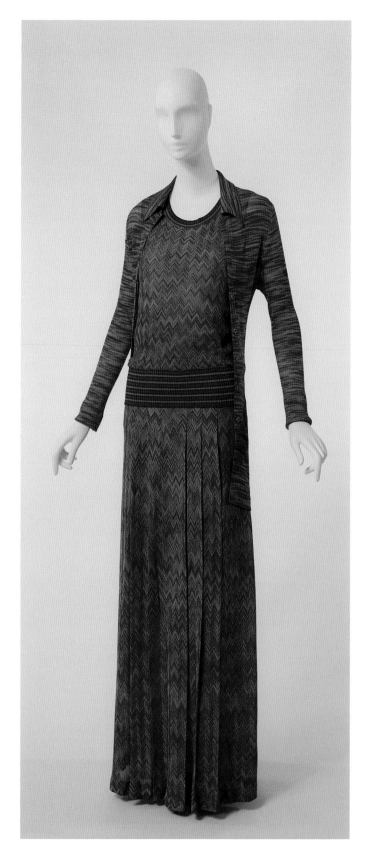

above left

MISSONI

Sleeveless tunic and matching skirt in multicolored striped rayon knit, 1962. The Museum at The Fashion Institute of Technology, Gift of Catherine di Montezemolo, 88.79.1.
Photograph by Irving Solero

above right and facing page

MISSONI

Three-piece sweater set with jacket, sleeveless top, and long, pleated skirt in flame pattern knit, 1973. The Museum at The Fashion Institute of Technology, Gift of Helen Rolo, 84.122.4.
Photograph by Irving Solero

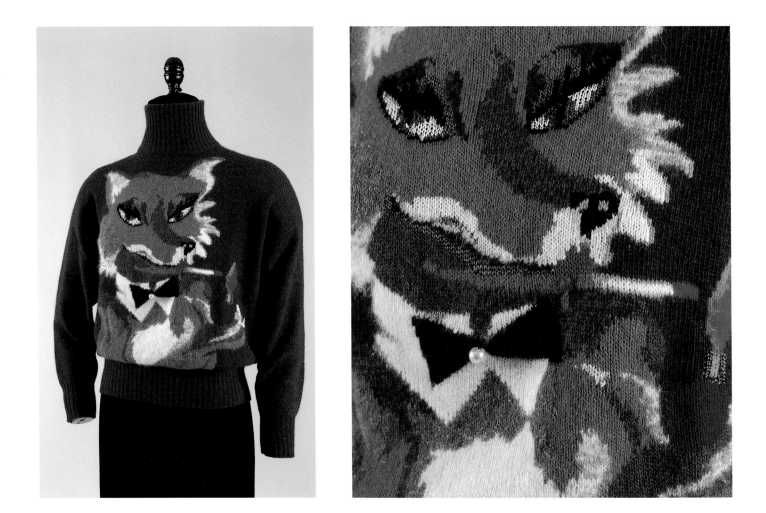

KRIZIA
Fox sweater in wool, silk,
and angora knit, 1984–85.
The Museum at
The Fashion Institute of
Technology, Gift of
Lisa M. Bassis, 93.162.2.
Photograph by
Irving Solero

The Missonis presented their first collection at the Pitti Palace in 1967, but Rosita Missoni did not like the way the models' underwear showed through her thin knitted dresses, so she told them to take off the underwear. Under the bright lights of the runway, the clothes looked transparent – and the Missonis were not invited back to Florence. Soon they helped to spearhead fashion's migration to Milan.

According to Mariuccia Mandelli of Krizia, at this time there still existed in Italy an "age-old inferiority complex with regard to France. People had the idea that prêt-à-porter was unworthy of fashion shows. In those days, only haute couture was shown in Rome." The artificial division between Rome and Florence seemed to provide only a limited venue for stylish ready-to-wear. Although Krizia's 1964 black and white collection in Florence won a prize, Mandelli was ultimately dissatisfied with the situation there, so she talked with the Missonis and a few others, and "they all said: all right, we'll show in Milan, too."[40]

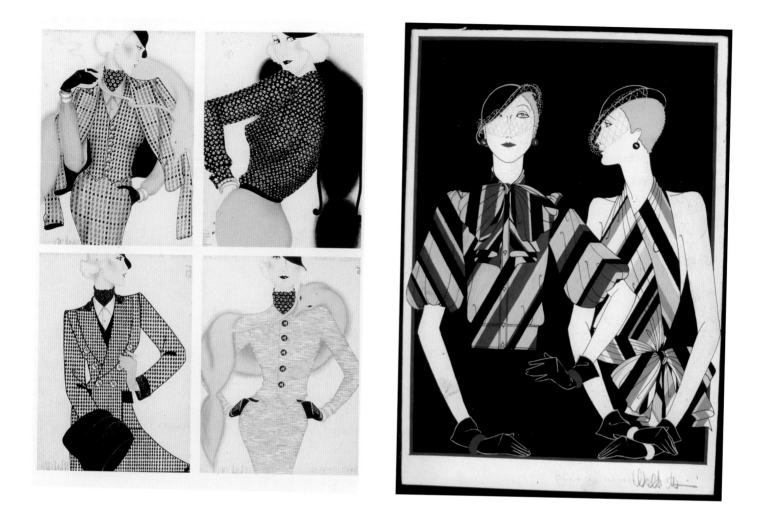

ALBINI
Original drawings by
Walter Albini for his
collections for Winter
1970/71 (above left) and
Winter 1974 (above right).
Courtesy of Paolo Rinaldi

Not only the venue but the model of production also changed, with the rise of the "stylist." It has been said that the first true stylist was Walter Albini (1941–1983). Although his life and career were cut short, Albini was influential in launching Italian ready-to-wear in the 1960s and 1970s. As a young man, he insisted that he be admitted to study at a fashion school in Turin – despite its being an all-girls school. Then he went to Paris for three years, just to "watch people," supporting himself by selling fashion sketches. Returning to Milan in 1964, he began designing as a free lance for various Italian companies including Krizia, Billy Ballo, Basile, Callaghan, and Mister Fox.

In 1968, Albini was represented at the Pitti Palace by five collections for five different companies. By 1972, however, he had joined the exodus to Milan. Already the center of production for the new ready-to-wear, Milan became a place to exhibit fashion. However, there was no longer a designated setting, such as the Pitti Palace.

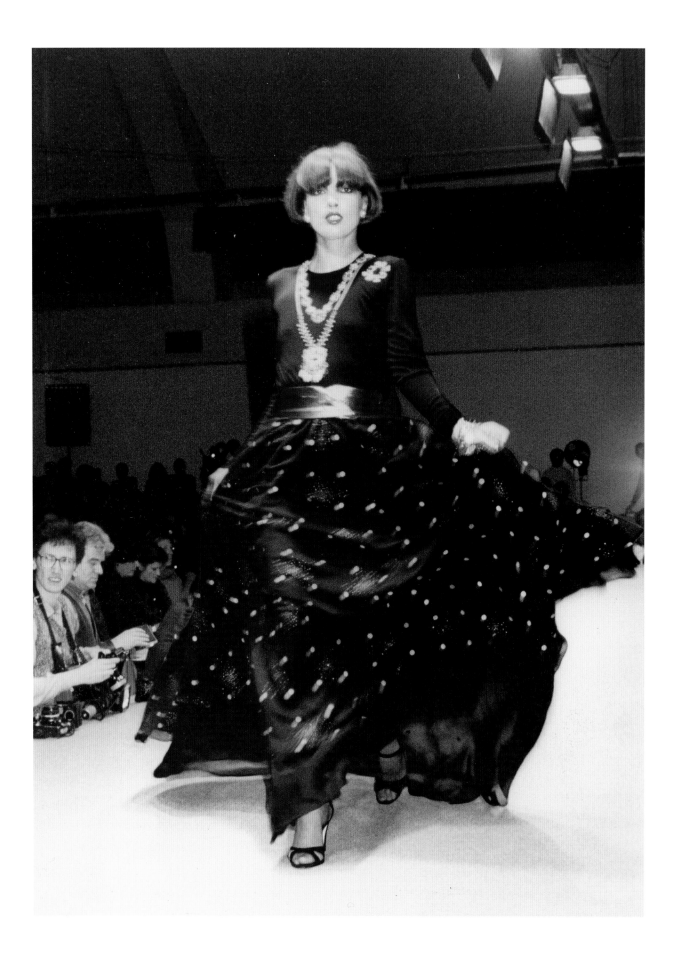

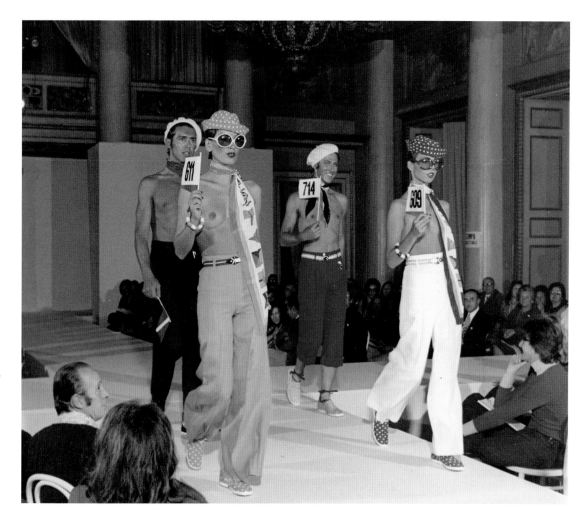

facing page

WALTER ALBINI
Gown and embroidered
trompe l'oeil t-shirt, Winter
1979. Courtesy of
Paolo Rinaldi

right

WALTER ALBINI
Winter 1974. Courtesy of
Paolo Rinaldi

The Milan fashion shows were like "happenings" staged in a variety of venues. Once, for example, Albini showed in a hotel room. In addition to his collaborations and consultations, Albini also produced a collection under his own name. He proposed many styles for many women. But behind the variety, there was always an Albini style. Often dressed like a character from an F. Scott Fitzgerald novel, he was obsessed by the fashions of the 1920s and 1930s, an era that he regarded as revolutionary. He had a lifetime preoccupation with Coco Chanel. Another of his passions was ancient Egypt, and many of his collections were inspired by exotic travel, especially to North Africa.

"Walter Albini played a huge role in Italian fashion," says Franca Sozzani, Editor in Chief of *Italian Vogue*. "But I think most people only really understood his importance after he died." In retrospect, however, it is clear that "in the late 1960s, he was virtually the only one doing the new *prêt-à-porter*. He introduced so many incredible things, and he made Italian fashion internationally known, at a time when most people only looked at the Roman couture."[41]

The Rise of Milan
and the "Italian Look"

The rise of the Italian ready-to-wear industry transformed Milan into one of the world's most important fashion capitals. Unlike Paris, Rome, and Florence, Milan was never a glamorous center of art and culture. Inventing a Milanese fashion image necessitated focusing precisely on the fact that Milan is an industrial city. By the early 1970s, fashion magazines and newspapers in America focused much less on the Roman couture and much more on ready-to-wear trends coming out of Milan. "The Italians were the first to make refined sportswear," recalled publisher John Fairchild. "Americans don't mind spending, if the sweater is by Krizia or Missoni."[42]

"Weary of French fantasy clothes and rude treatment on Parisian showroom floors, buyers were happy to take their order books next door," reported *Newsweek* in 1978. The clothes coming out of Milan were, admittedly, not couture, but they were extremely stylish. "They were classically cut but not stodgy: innovative but never theatrical," declared *Newsweek*. "They were for real people – albeit rich people – to wear to real places."[43] Beppe Modenese, sometimes referred to as "the Garibaldi of Italian fashion," has said that "Decadence is what goes down well in Paris. Milan is the present and the future. The French disguise the industry–designer relationship. We make it quite clear that the concrete side of the make-believe is achieved today through industry."[44]

Because the Italian textile industry focuses on luxury fabrics, there was a foundation for the upscale ready-to-wear fashion shown in Milan. In addition, textile producers gave financial backing to Italian clothing manufacturers, many of whom began to hire freelance fashion stylists to create collections that were neither couture nor mass market. Many designers and companies contributed to the development of the "Italian Look." Indeed, not all the designers involved were Italian, since many companies initially hired foreign designers. However, Italians were particularly influential, above all Giorgio Armani and Gianni Versace.

Giorgio Armani influenced the world of fashion first through his menswear designs. Indeed, he revolutionized the way men and women dressed in the 1970s, in part by making them look more like each other. As his former employer Nino Cerruti says, Armani "became a flagship for success in Italy. From 1974 onward, he and Versace were the symbols of a dramatically growing Italian fashion. He was much closer to people with a normal life. Versace was for a more extreme audience."[45]

When Giorgio Armani was featured on the cover of *Time* in April 1982, the American journalist Jay Cocks began his article by asking Pierre Bergé, the business partner of the French designer Yves Saint Laurent, about Italian fashion. Bergé insisted that except for "pasta and opera, the Italians can't be credited with anything!" And what about Armani? "Give me one piece of clothing," Bergé demanded, "one fashion statement that Armani has made that has truly influenced the world." It was a rash challenge to make to an American journalist, who had probably chosen to interview Bergé in the hope that he would criticize Armani, and Cocks impudently replied, "Alors, Pierre. The unstructured jacket. An easeful elegance . . . Tailoring of a kind thought possible only when done by hand . . . A new sort of freedom in clothes."[46]

Made-to-measure Italian menswear had long been recognized for the quality of its materials and workmanship. Part of the success of the Italian Look in the 1970s was based on the development of luxurious menswear available off the rack. As *Esquire* put it in 1979, Italian designers like Armani provided a "rich, relaxed style."[47] The fashion writer Woody Hochswender has observed that the Italian Look "came to bridge the gap between the anti-Establishment 60's and the money-gathering 80's."[48] Milan showed clothes that were as casual and relaxed as sportswear, but also luxurious and prestigious. The perceived eroticism of Italian style was also related to the way these clothes idealize the body, in a way that had previously been "the prerogative of the rich," since only they could afford the custom tailoring that concealed figure flaws.[49] Now luxury ready-to-wear offered the same promise.

"Armani disarmed men and their clothes erotically without unmanning them," wrote the American journalist Judith Thurman. "He freed them to be looked at and desired by women (and other men)."[50] In place of stiffly tailored business suits, symbolizing rectitude and bourgeois masculinity, Armani introduced softer jackets,

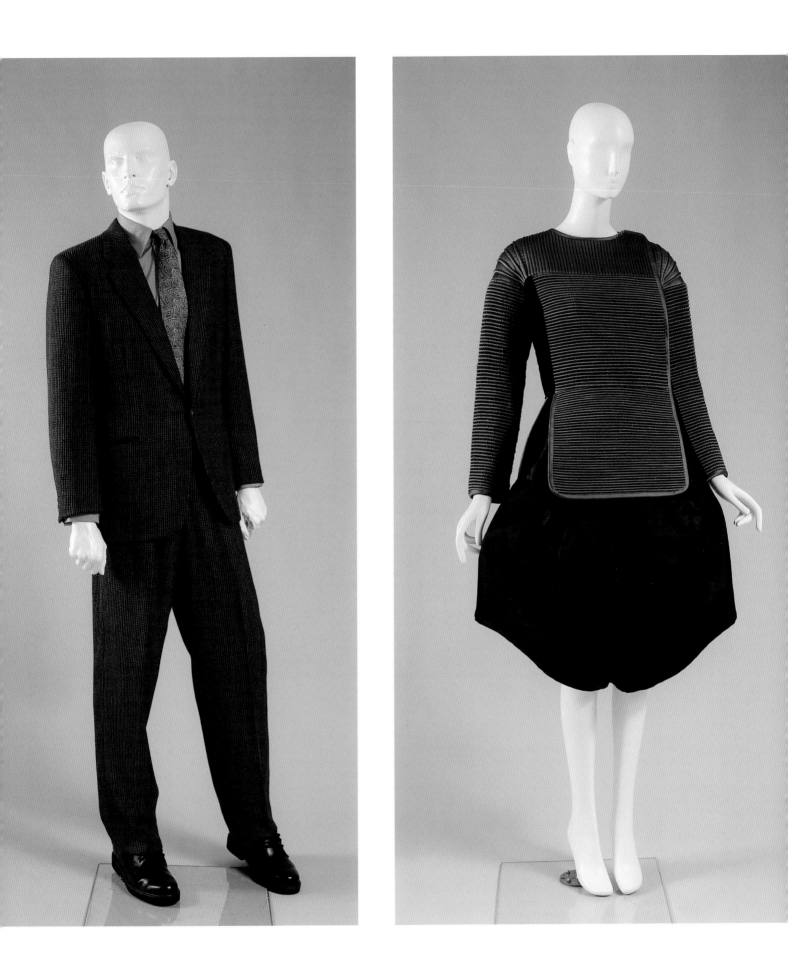

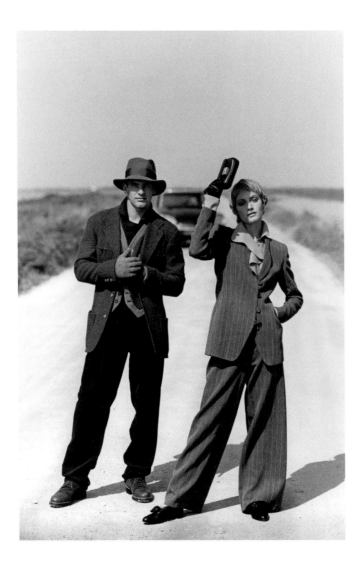

above left

GIORGIO ARMANI
Fall/Winter 1993–94. Photograph by Peter Lindbergh, courtesy of
Armani

above right

GIORGIO ARMANI
Spring/Summer 1991. Photograph by Aldo Fallai, courtesy of Armani

without padding and stiff interlinings. Of course, Armani was not the only Italian designer to utilize luxury fabrics, such as cashmere and silk-and-wool blends, which drape softly and have greater tactile appeal than stiffly woven wools. However, he received unprecedented publicity, especially through his association with Hollywood. Particularly significant was the film *American Gigolo*, which presented the actor Richard Gere as a male sex object who dressed exclusively in Armani. No fewer than thirty Armani suits were featured in the film, and according to Thurman, Gere's "shopping trips provided the film's true sexual excitement." Not only was Armani's menswear immediately recognizable to the movie audience, but the clothes were "also perceived as being in the realm of values."[51] In other words, people knew that Armani clothes signified casual, expensive, sexy elegance. No wonder Jack Nicolson, Dustin Hoffman, John Travolta, and Richard Gere were eager to tell the journalist from *Time* about their own Armani clothes.

No sooner had Armani "feminized" (or eroticized) menswear than he interpreted his menswear look for the female consumer. Although hardly the first or only designer to apply men's tailoring to women's clothes, Armani has probably had the greatest impact of anyone since Coco Chanel. Beginning with his first womenswear show in 1975, and really getting under way in 1979, when he showed draped tailored jackets, Armani dressed women in fashions directly inspired by menswear classics – *his* menswear classics. Armani "has taught a woman to dress with the slouchy ease of a man," declared *W*.[52] He gave professional women the same kind of subtly powerful uniform that men had.

Tailor Made – in Naples, Rome, and Milan

Of course, long before Armani removed the lining from traditional men's suits, thereby launching his fashion revolution, Italian tailors in Rome and Naples had been making jackets that – as the Neapolitan tailor Cesare Attolini has said – felt "like cardigan sweaters, not armor."[53] The Neapolitans have been tailoring clothes since the fourteenth century. "Our tailoring is a mix of the French, English, Spanish and Italian traditions. We took the best from everyone," says Antonio De Matteis of Kiton, the Neapolitan suitmaker. Founded twenty-five years ago by Ciro Paone and Antonio Carola, Kiton suits feature details such as handsewn seams. Kiton's production is strictly limited by the attention to craftsmanship. In addition to its suits, Kiton is known for handmade silk neckties.

Tailoring has always been central to Italian fashion. If Armani is about style, a company like Zegna focuses on fabric development and quality. In 1968, Zegna made the decision to combine their tradition of superlative fabrics with the renowned Italian tailoring. Today the company oversees all stages of production in a vertical structure: they gather the materials, make the fabrics, produce the clothes, and sell them through a network of Zegna boutiques. Of course, many other Italian companies also specialize in tailored clothes for both men and women. The country

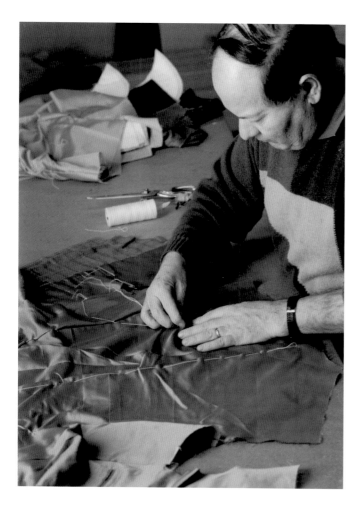

above left and right

Tailors at the Kiton factory just outside Naples. Courtesy of Kiton

KITON
Suits, 2000. Courtesy of Kiton

ERMENEGILDO ZEGNA
Chalk stripped wool suit,
c. 1998. Lent by Dean
Joseph S. Lewis, III.
Portrait of Dean Joseph S.
Lewis, III by Irving Solero

sporting clothes of Beretta, for example, draw on northern Italian aristocratic traditions, and are as impeccably produced as their famous weapons. Young fashion designers also appreciate the importance of tailoring traditions. The young Sicilian-born designer Maurizio Pecoraro, for example, learned pattern-making from a tailor, and staged his first runway show in 2002. Ennio Capasi of Costume National subtly combines classical tailoring with new proportions and fabrics.

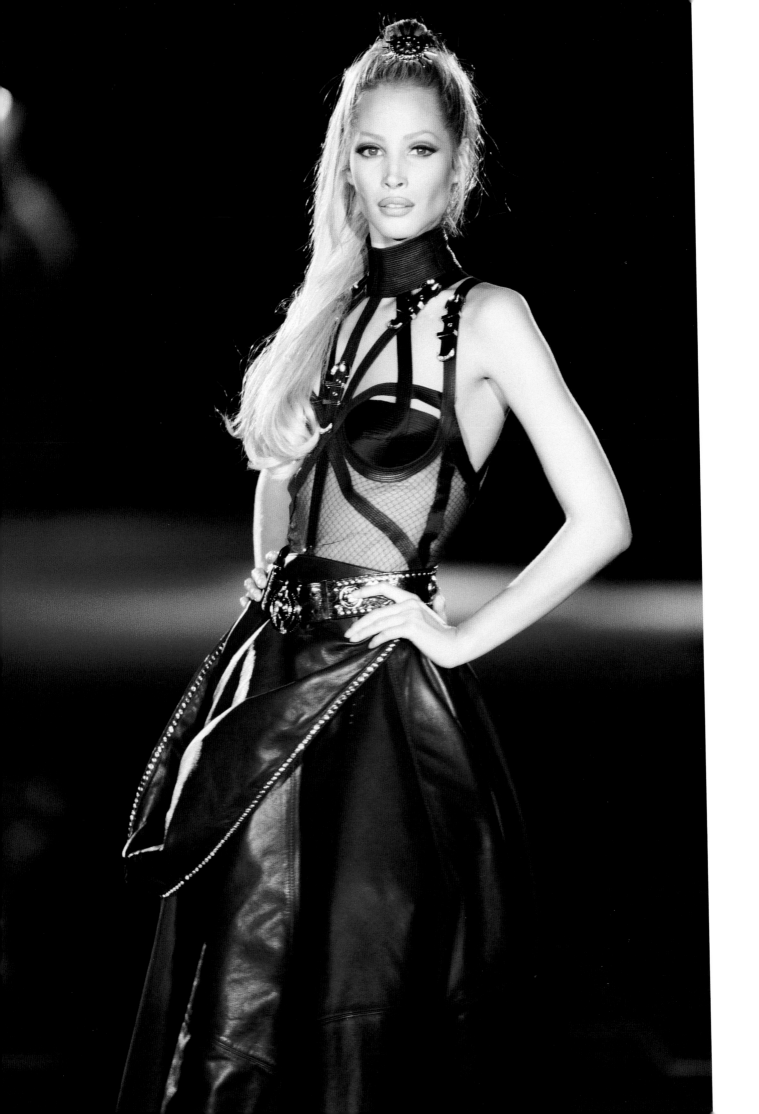

A Fellini-like Sensuality

facing page

VERSACE
Fall 1992. Photograph by
Maria Chandoha Valentino

page 72

GIANNI VERSACE
Detail of suit with straight
line jacket in blue wool
with deep PVC yoke and
matching pants, c. 1983.
The Museum at
The Fashion Institute of
Technology, Gift of Howard
Froman, 90.128.2. Photo-
graph by
Irving Solero

Asked to define Italian style, Armani used the word "subtle." Italian elegance lay "in the details, not in-your-face."[54] By contrast, Gianni Versace (1946–1997) "made all the world a stage for flamboyant and fascinating costume . . . a Fellini-like sensuality . . . and the brilliant notes of operatic color," wrote the fashion historian Richard Martin.[55] Born in Reggio Calabria, in the south of Italy, Versace first became acquainted with fashion by assisting at his mother's dressmaking company. After freelancing for companies such as Callaghan and Complice, he founded his own label in 1978. Like many Italian fashion companies, it was a family business, in which Gianni worked together with his brother Santo and his sister Donatella.

During the 1990s, Gianni Versace became perhaps the world's most famous exponent of sexually expressive clothing for both men and women. As Martin observed, "Versace chose as his heroic female model the prostitute or streetwalker" transfigured into media star.[56] He audaciously introduced into high fashion certain stylistic elements hitherto associated with homosexuality and sadomasochism, such as leather harnesses. His use of leather, a tactile animal material, was especially influential. Traditionally used primarily for items such as jackets, leather, in Versace's hands, was equally appropriate as eveningwear. Versace also exerted an influence on both men's and women's fashion with his brilliantly colored silks featuring a baroque exuberance of design.

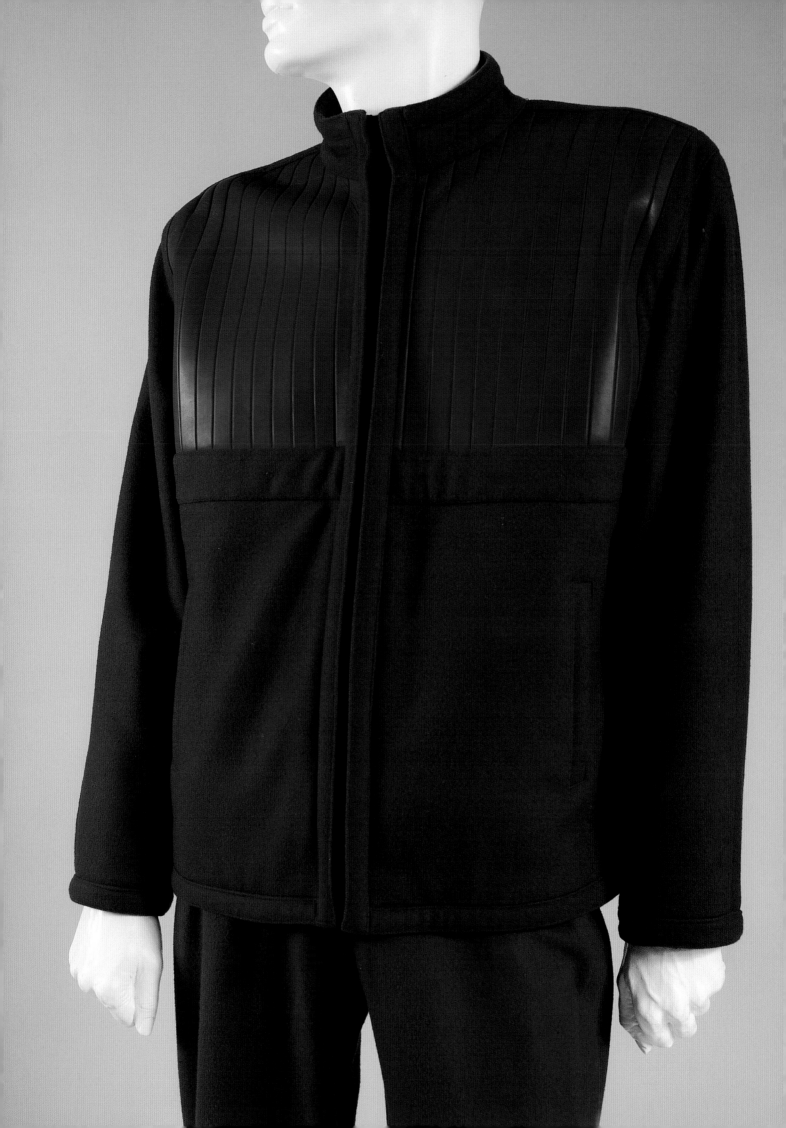

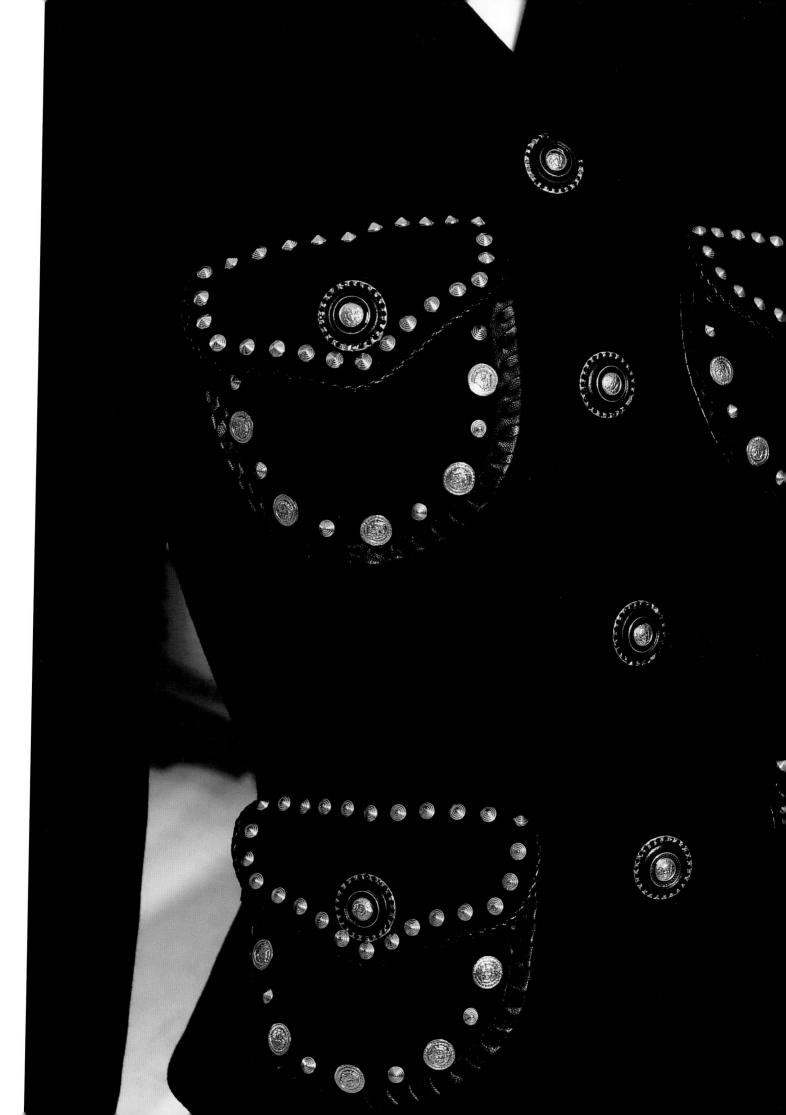

GIANNI VERSACE
Detail of lack wool crepe
cowboy suit with brass and
leather trim, 1992. The
Museum at The Fashion
Institute of Technology, Gift
of Judith Corrente and
Willem Kooyker, 98.20.5
and 98.20.7. Photograph by
Irving Solero

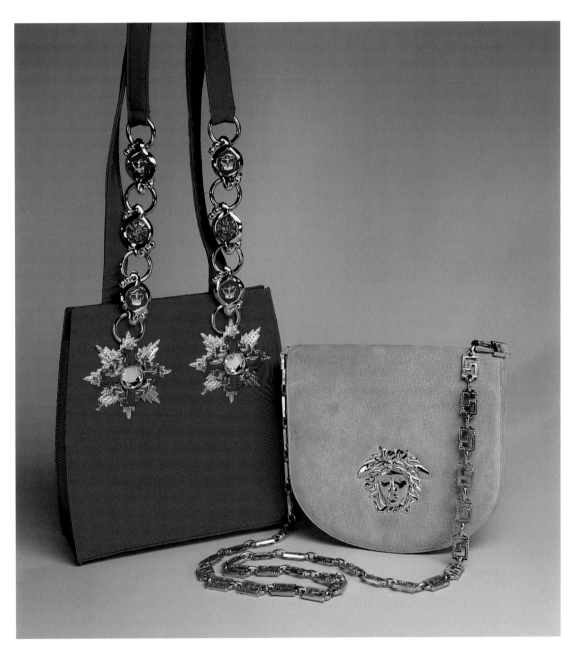

facing page

GIANNI VERSACE
BOUTIQUE
Detail of suit in turquoise silk with single-breasted
jacket, wide draped pants, and cotton shirt with
flowered vine-patterned stripe, c. 1992. The Museum
at The Fashion Institute of Technology, Gift of
Judith Corrente and Willem KooyKer, 98.20.11.
Photograph by Irving Solero

above

GIANNI VERSACE
Red silk faille tote-style shoulder bag with metal and
enamelled insignia, c. 1992. Chartreuse suede shoulder
bag with V and Medusa logo. The Museum at The
Fashion Institute of Technology, Gift of
Judith Corrente and William Kooyker, 98.101.2 and
98.101.1. Photograph by Irving Solero

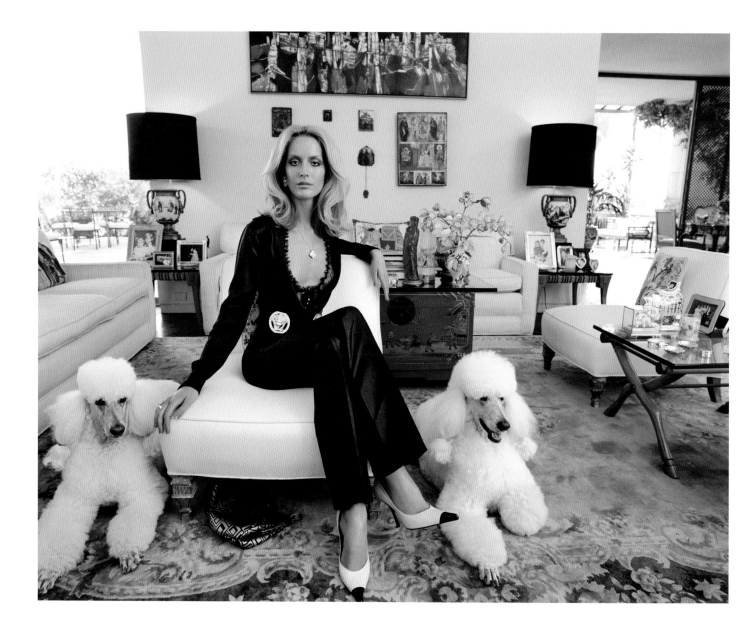

After Gianni Versace was murdered in 1997 in Miami, his sister Donatella became the company's head designer. Having collaborated closely with her brother for many years, she was able to build on his aesthetic, while also making her own contributions to the Versace style. Popular music, for example, had always been a passion of Gianni, but became central to Donatella's style. When the curvaceous singer Jennifer Lopez wore a revealing dress by Donatella Versace to the Oscar awards ceremony in 2001, the image on millions of television screens instantly became at least as notorious as the vision of Elizabeth Hurley in Gianni Versace's 1994 safety-pin dress. These two dresses have entered fashion history.

VERSACE
Fall/Winter 2000–01.
Photograph by
Steven Meisel. Courtesy of
Versace.

Another of the fashion world's irreverent free spirits was Franco Moschino (1950–1994). Moschino worked as a freelance designer and fashion illustrator for a number of Italian companies, including Versace, before launching his own company in 1983. Several years later, he started a secondary line, Cheap and Chic. He was as much a social commentator as a fashion designer. Like Schiaparelli, he often began with classic clothes and then subverted them with surrealistic details. Typical Moschino designs mocked fashion victims. For example, a jacket had its *raison d'être* spelled out in bold embroidered letters: EXPENSIVE JACKET. A belt announced WAIST OF MONEY. "Fashion should be fun," he told *Women's Wear Daily*. "And it should send a message."[57] His messages were not always appreciated. When he produced a tee-shirt printed with CHANNEL N° 5 on a television screen, he was successfully sued by Chanel. Nor was Vuitton amused when he designed a brown-and-gold handbag covered with Ms instead of LVs.

"The world has enough fashion to go on for centuries. Fashion needs a diet," declared Moschino. Even before he began his own line, he asked himself, "Was it right to offer up more clothes . . . ? And the answer was, no. What people needed, more than new clothes, was a new way to wear them."[58] Rather than inventing new clothes, he proposed putting things together in a new way, such as a chic couture-style jacket paired with jeans, or a leather biker's jacket over a ballgown. Moschino's theme song, which played at his early shows, was "I Am What I Am" from *La Cage aux Folles*, and, in a sense, his message was Be Yourself!

Often referred to as a gadfly and an anarchist, Moschino vociferously denounced what he called the "fascism" of the fashion system – with the ironic result that he was catapulted to the top of the very system he mocked. His advertising campaign for Spring/Summer 1990 featured a vampire splattered with blood-like red ink and a giant red X over her face alongside the caption "Stop the Fashion System!" His target, Moschino explained, was "the system that wants you to be a transvestite every morning, in a different way." The alternative: "A clothing system that would let people be more free about the clothes they wear."[59] It could be argued, of course, that the success of the Italian fashion system helped provide just such freedom of choice by enabling a variety of designers to create in their own individual styles.

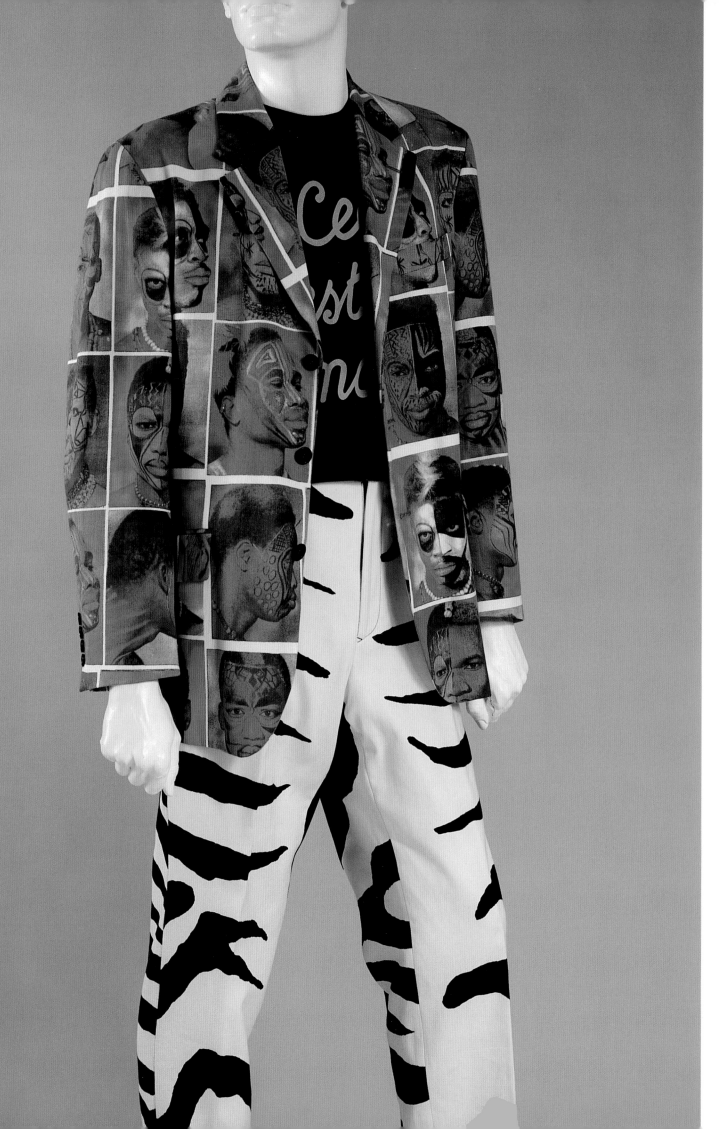

The Italian Fashion System

The star system of high-profile fashion designers who show in Milan is only the tip of the iceberg when it comes to the Italian fashion system. Equally important are financiers and manufacturers. For example, Max Mara SpA was founded by Achille Maramotti in 1951 in Reggio Emilia, and has since become one of Italy's most successful fashion companies. The Max Mara design philosophy is understated, producing easy-to-wear clothes such as tailored suits and coats in luxury fabrics. Achille's son, Luigi Maramotti, says, "Our customers are led by fashion, but are never its slaves."[60]

Zamasport SpA was founded in 1966 as an offshoot of a family firm hitherto known as a manufacturer of knitted underwear. The Callaghan trademark was also invented in 1966, and immediately became known for innovative designs, created by stylists such as Walter Albini and Gianni Versace, among others. Callaghan was produced and distributed by Zamasport. Another important Italian fashion house is Byblos, which was founded in 1973 as a division of Genny SpA. Only industry professionals may recognize the names of industrialists such as Donata Girombelli, but in the 1980s she helped make Complice a successful fashion company. Many more such examples could be given.

Gianfranco Ferré became a star in the course of a single season, after he was backed by the Bolognese industrialist Franco Mattioli. "I believed in him, and for the firm I needed to invest," recalled Mattioli. "The very first show had to be successful,

otherwise the whole thing would collapse."[61] Giorgio Poli undertook Ferré's advertising campaign, hiring the photographer Herb Ritts and identifying the image to present in chosen publications. The women's collection was launched in 1978, and the menswear collection in 1982. Named artistic director of the house of Dior in 1989, Ferré won a Golden Thimble award in Paris before returning to work in Italy.

Described by *Women's Wear Daily* as "the Frank Lloyd Wright of Italian Fashion," Ferré trained initially as an architect. His clothes are characterized by bold, dramatic lines and luxurious materials. He is especially famous for his glamorous white shirts. Yet despite a pronounced theatrical flare, he is also practical. On hearing Diana Vreeland's famous quip "Pink is the navy blue of India," Ferré sensibly observed: "Naturally pink is the navy blue of India, because it's the cheapest of dyes."[62] He has expressed reservations about the Italian industrial model. "In Italy, in Milan, you can see three collections designed by the same designer; one will be signed by him, and the other two will carry industrial labels. There will be certain ideas in the one collection, and the same or just slightly different ones in the others . . . Clothes produced by industries using a consultant may sell very well, but they shouldn't be placed on the same level as those actually signed by the designer."[63]

In Italy, fashion is produced "at all levels," counters the industrialist Mario Boselli, "yarns, fabrics, knitwear, and garments. Our designers are surrounded by an industrial system that gives them everything they need. And when you think that for years people used to say that the textile sector was getting long in the tooth, had had it, should be left to the Third World!"[64] Not only are there many internationally famous Italian brands, but the quality of fashion production throughout Italy is extraordinarily high. It is virtually impossible in Italy to find ugly or poorly made garments or accessories. Moreover, some designers create true works of art. Romeo Gigli, for example, is known for the Renaissance luxury of his extraordinarily beautiful fabrics. Trained in architecture, Gigli uses these materials to create silhouettes that are always harmonious.

High-quality materials are a necessary but not sufficient prerequisite for superior fashion. Missoni, for example, might acquire twenty different yarns for any given collection. The yarns are then dyed in a variety of shades. The models are made up on handlooms, and then the actual garments are produced on industrial looms, which have been equipped to deal with complicated designs and mixtures of material. As Ottavio Missoni says, "They're machine-made garments, but they have a hand-made look about them."[65] To excellent materials must be added excellent design applied to industry.

Another major knitwear designer is Laura Biagiotti, known as "the Queen of Cashmere," who lives and works in a factory-castle near Rome. She is widely credited with having invented fashionable cashmere, since previously cashmere had been used only for classic styles such as twin-set sweaters. Her compatriot Anna Molinari is

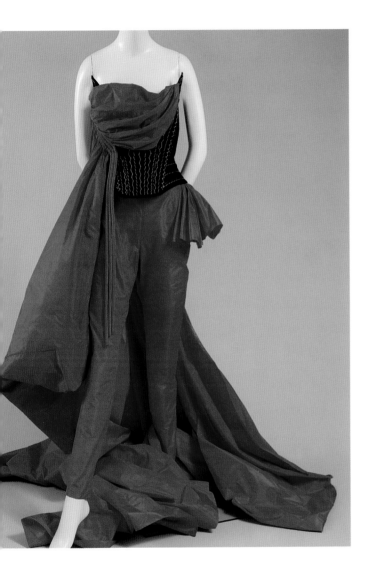

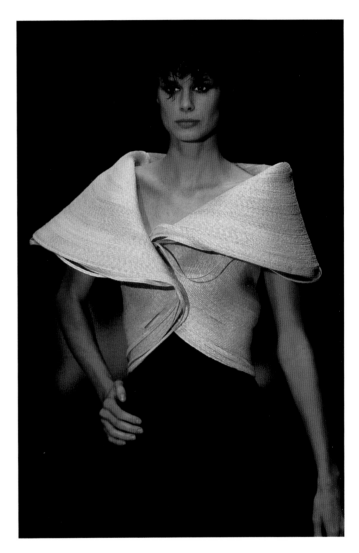

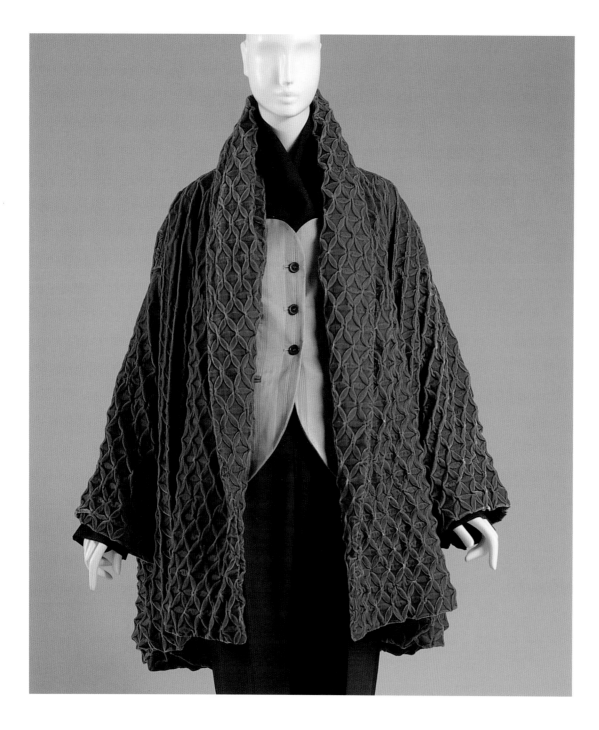

above and facing page

ROMEO GIGLI
Green velvet coat and ensemble, Fall/Winter 1991–92.
The Museum at The Fashion Institute of Technology, P91.53.1.
Photograph by Irving Solero

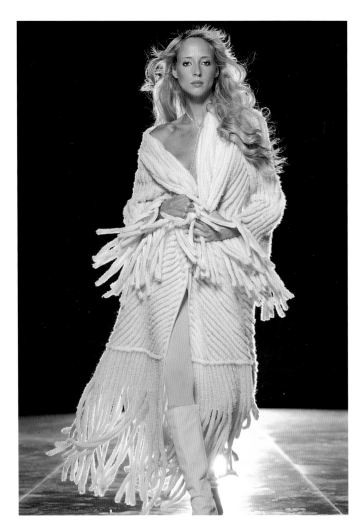

above left

LAURA BIAGOTTI

"Motif for a lampshade" from the Balmoda collection. Photograph by Graziella Vigo, courtesy of Laura Biagotti

above right

LAURA BIAGOTTI

White cashmere long coat with fringes, Fall/Winter 2000–01. Photograph by Marco Glaviano, courtesy of Laura Biagotti

facing page

BLUMARINE

Fall 1995. Photograph by Maria Chandoha Valentino

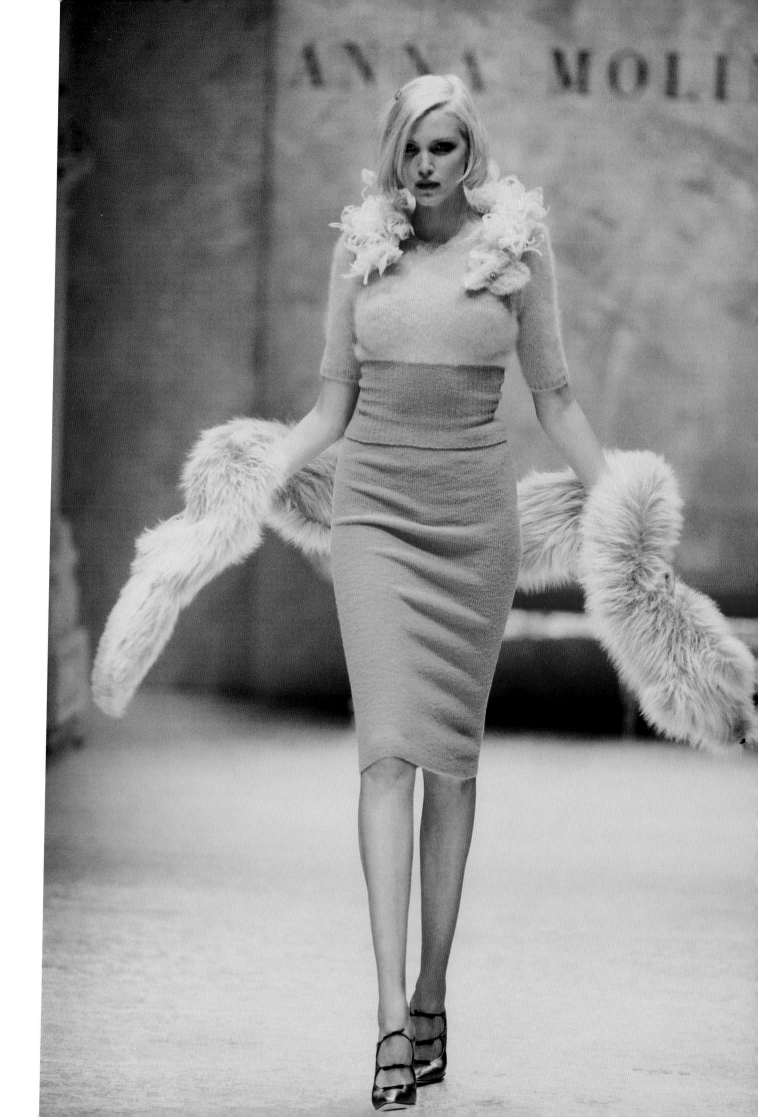

known as "regina della rose" (queen of the roses) for her beautiful floral sweaters. Originally from Carpi, she grew up working in her family's knitwear company and opened her own company, Blumarine, in 1977. Although still known for stylish sweaters, Molinari has moved beyond her origins in knitwear.

Underwear, like knitwear, is revolutionized by the introduction of a fashion sensibility. When La Perla was founded in Bologna in 1954, the city already boasted a strong craft tradition going back four centuries, based on a flourishing textile industry. The existence of a local silk industry led to the foundation of a famous women's corsetry school in the eighteenth century. Building on this tradition, Ada Masotti opened a workshop – which she named La Perla – that manufactured women's underwear made in brightly patterned silk decorated with lace.

Known for its jeans, the fashion brand Diesel, founded by Renzo Rosso, is perhaps even more famous for its witty marketing communications, such as a brochure suggesting that "Shopping is the Meaning of Life." Benetton's global image has also been strikingly influenced by its often controversial advertising campaigns.

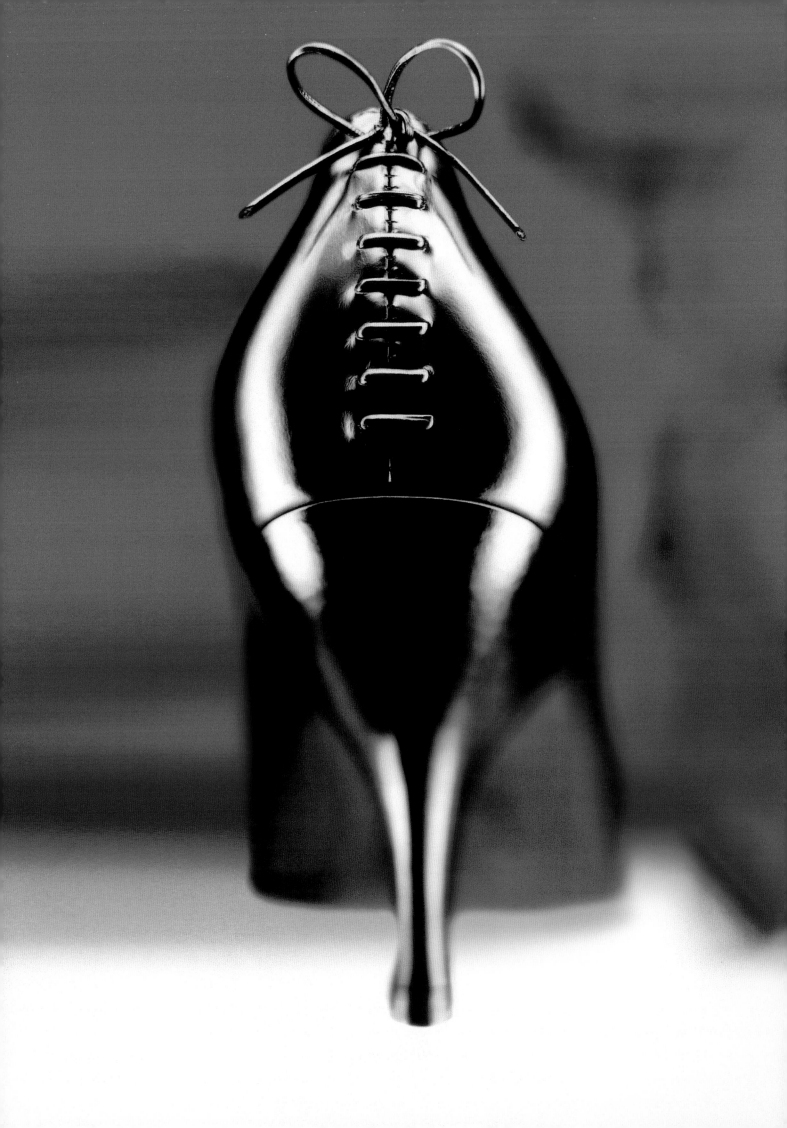

Accessories Are More Important Than Ever

Accessories, especially shoes and handbags, have long played a central role in the Italian fashion system. In the case of Gucci, accessories provided the foundation for expansion into high fashion and, ultimately, the creation of one of the world's most successful fashion empires – which is internationally synonymous with luxury, status, and sex appeal. If Franco Moschino were alive today, he might be spoofing Gucci, instead of Chanel.

Yet the venerable Florence leather company has seen ups and downs as vertiginous as a rollercoaster. The double-G motif, together with Gucci's bold red and green bands, were international symbols of prestige in the postwar years. Gucci handbags and loafers were especially potent icons of success. But indiscriminate expansion and the proliferation of Gucci imitations, along with the notorious conflicts among members of the Gucci family, drove the company into a dramatic decline, which was reversed only in the 1990s after the American designer Tom Ford joined the company.

Today accessories are more important than ever throughout the world of fashion. While some consumers still wear head-to-toe designer fashion, others focus on the prestigious and desirable accessory of the season. After all, that sexy Gucci outfit that triumphed on the runway in Milan may be a little hard for the average woman to

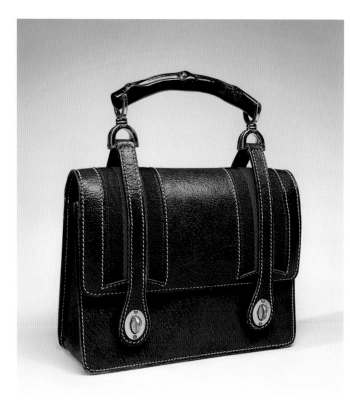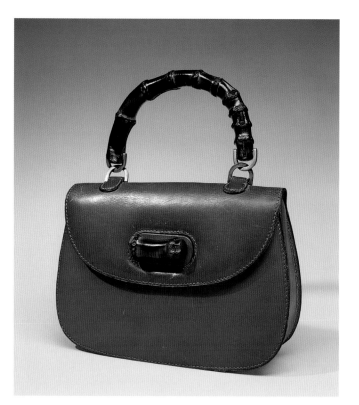

wear, but she can get a lot of fashion excitement from the latest Gucci bag or shoes. In fact, many women actively collect pairs of shoes and handbags which they use to individualize their ensembles. There are a number of manufacturers and regions in Italy specializing in the production of high-quality leather accessories – both for Italian fashion companies and for a wide variety of French and American companies. Although foreign tourists are most familiar with Florentine leather shops, the area around Venice is another center of leather production. The Shoemakers' Association of the Riviera del Brenta represents many manufacturers in that region, who produce shoes for some of the world's illustrious fashion companies. Anyone who visits a shoe factory there cannot fail to be impressed by the combination of hand craftsmanship and technological sophistication that goes into the production of, say, a pair of Gucci shoes.

In contrast to the internecine struggles of the Gucci clan, the Fendi sisters and their descendants have thus far successfully negotiated the evolution of the family business, from a small fur and leather workshop (established in Rome in 1918) to a world-famous luxury goods company. The business was founded by Adele Fendi, who took her daughters to work. "Accessories were our first toys," recalled Carla Fendi. When Adele handed over the company, she told her daughters, "Girls, design whatever

above left

GUCCI
Envelope bag in dark brown leather with red and green twill insets and curved bamboo handle, c. 1967. The Museum at The Fashion Institute of Technology, Gift of Mrs. James Levy, 83.144.28. Photograph by Irving Solero

above right

GUCCI
Brown leather handbag with rigid painted bamboo handle and twist clasp, c. 1972. The Museum at The Fashion Institute of Technology, Gift of Lauren Bacall, 80.71.78. Photograph by Irving Solero

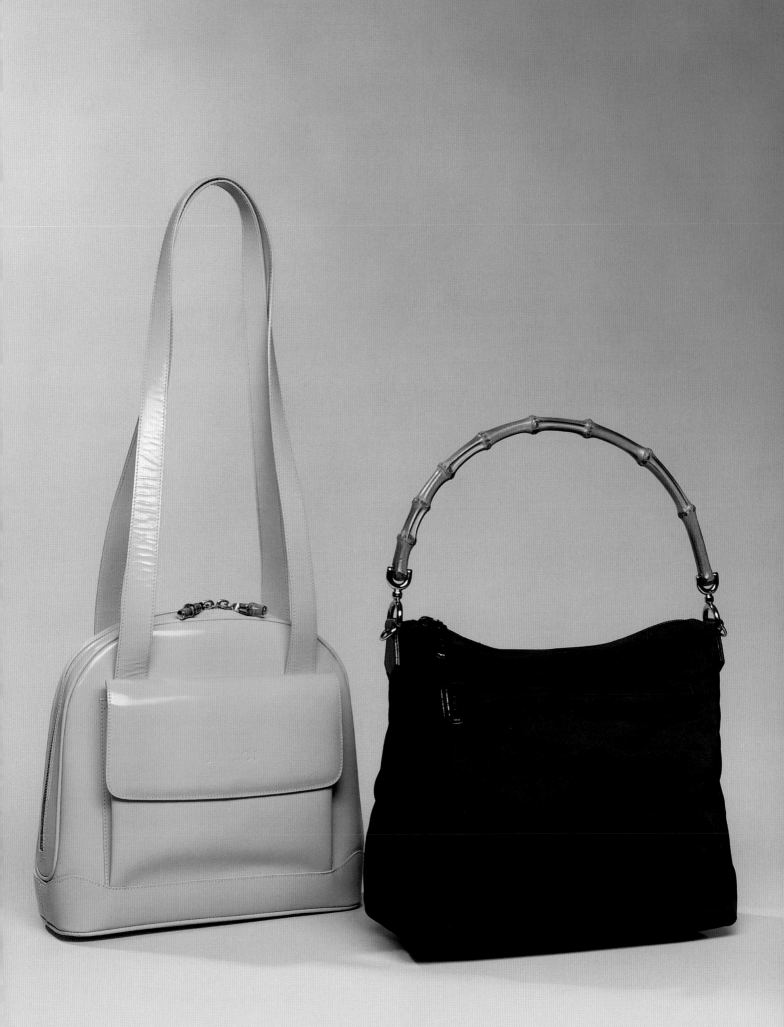

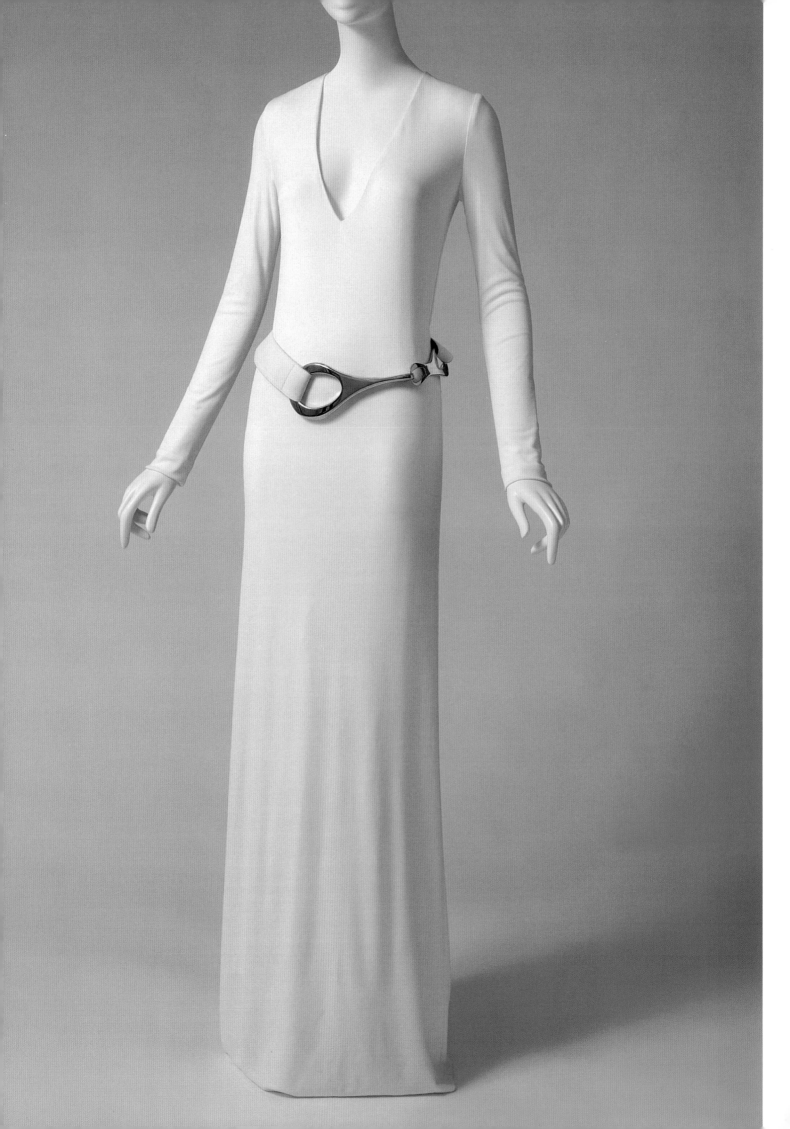

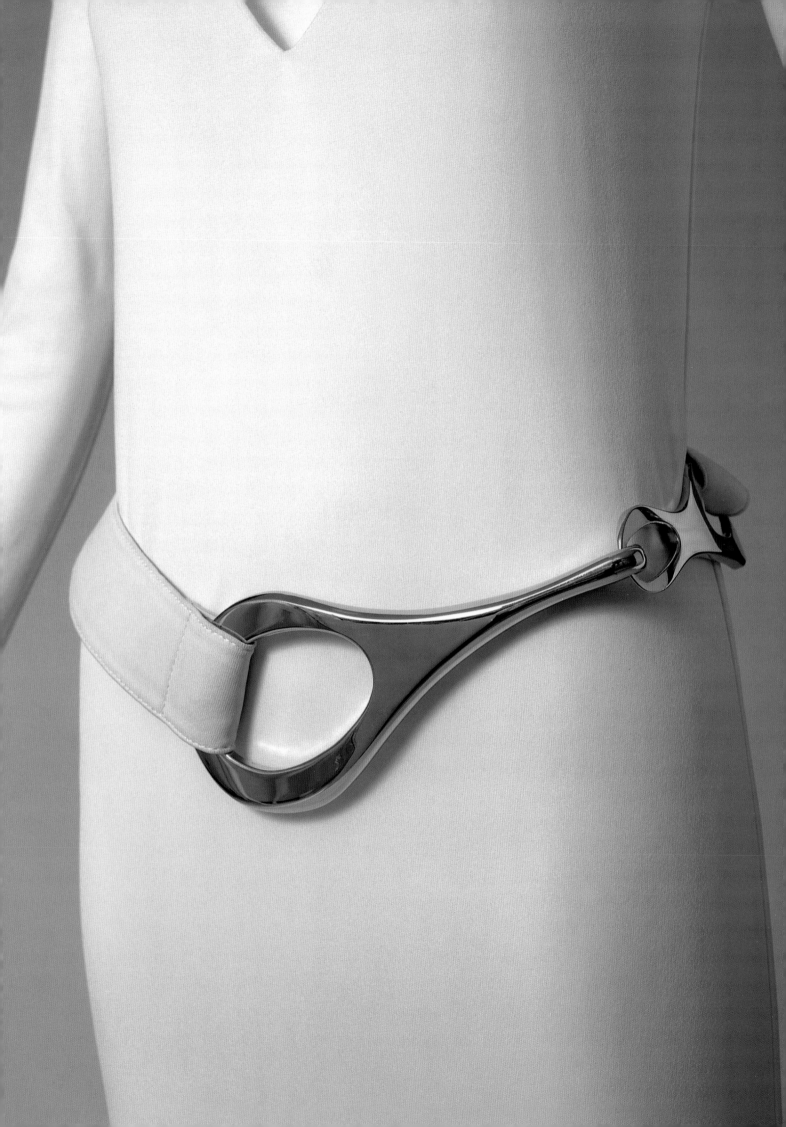

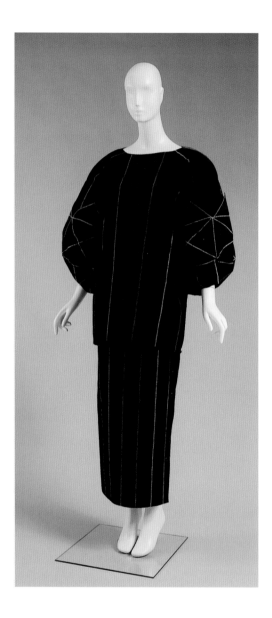

pages 94 and 95

TOM FORD FOR GUCCI
White matte jersey full-length evening dress with
contour belt, Fall/Winter 1996–97.
The Museum at The Fashion Institute of
Technology, Gift of Gucci Inc., 96.30.1.
Photograph by Irving Solero

above left and right

FENDI
Tunic and skirt in black silk faille with gray zig-zag stitch pattern, 1980–81.
The Museum at The Fashion Institute of Technology, Gift of Tina Chow, 91.255.6.
Photograph by Irving Solero

facing page

FENDI
Spring 2001. Photograph by Maria Chandoha Valentino

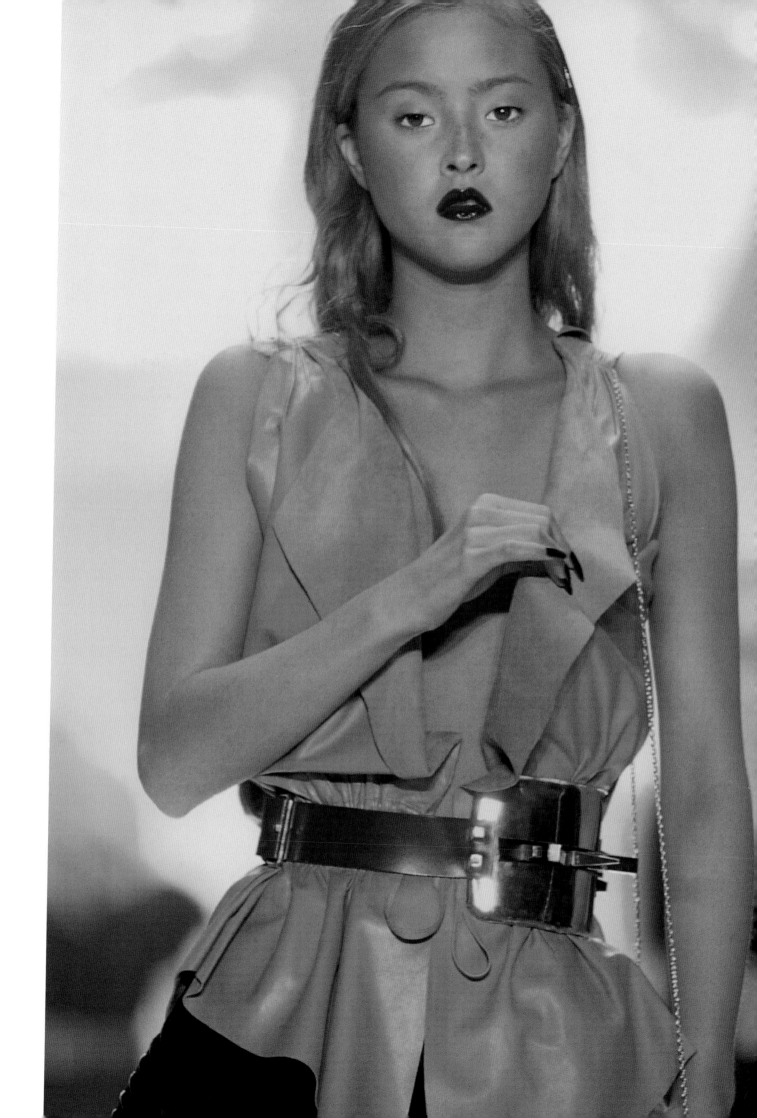

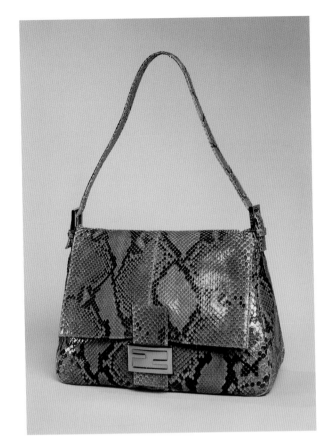

you want. Just make sure that it's high quality."[66] For many years now, Karl Lagerfeld has been designing Fendi's well-known leather and fur fashions.

Fendi's biggest success in recent years has been the Baguette shoulder bag, which had its debut in 1997. Designed by Silvia Venturini Fendi, creative director of the company and a granddaughter of the founder, the Baguette has subsequently appeared in more than 500 different styles – in materials ranging from denim to mink, and at prices from $500 to several thousand. Clients included Madonna, Sharon Stone, and Elizabeth Hurley.

Leather has become an increasingly vital sector of fashion, and Italian companies are well positioned to take advantage of this direction in style. Leather clothing began to be extremely fashionable in the 1970s, when Roberto Cavalli, based in Florence, first made an impact internationally with his printed leathers. Recently, Cavalli's exuberant styles have again captured the attention of fashion trendsetters. Other famous leather fashions of recent years have been those created for Gucci and Versace. Only fashion insiders know, however, that Versace's leather fashions are produced by a high-end leather company, called Ruffo.

Ruffo also produces its own line of clothing, cut by hand with surgical precision, as well as the experimental Ruffo Research line, which features a new young designer every year. Naturally, there are also Ruffo leather accessories. In fact, the list of Italian leather companies is legion, from Bottega Veneta, best known for intricately woven leather bags, to Cesare Paciotti, best known for ultra-sexy shoes.

FENDI
Brown python handbag,
c. 1980's. Lent in Memory
of Sally Solomon.
Photograph by
Irving Solero

facing page

ROBERTO CAVALLI
Fall 2000. Photograph by
Maria Chandoha Valentino

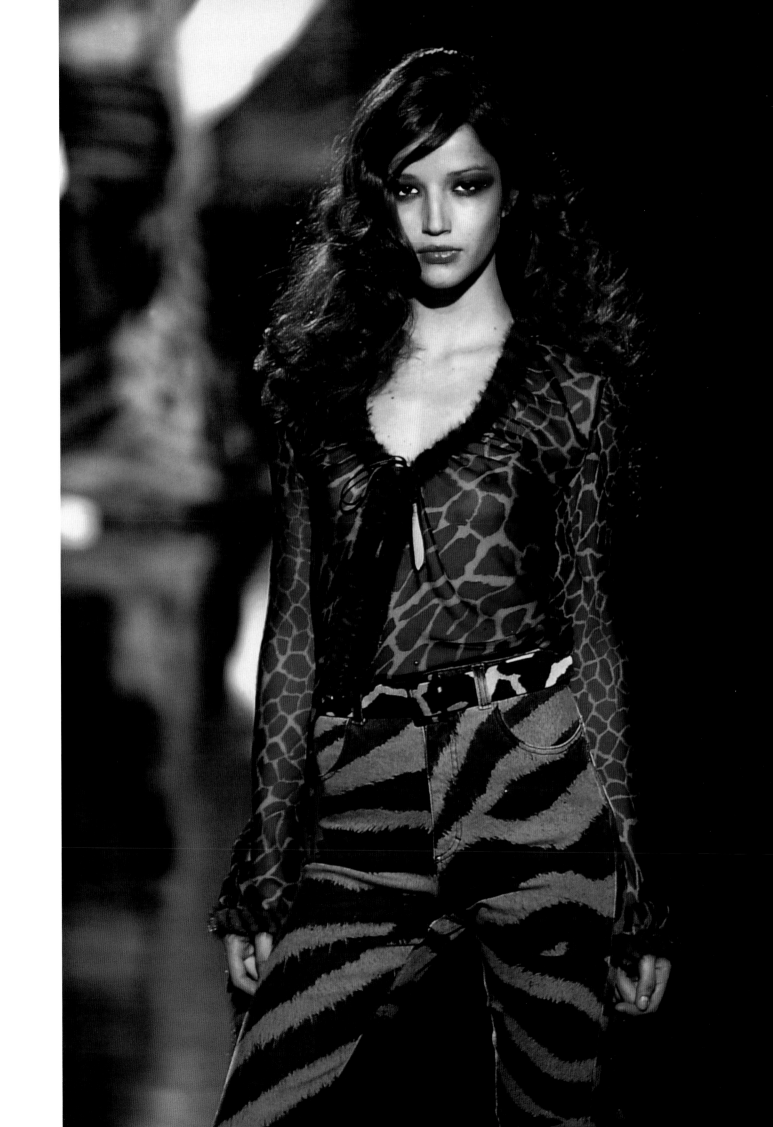

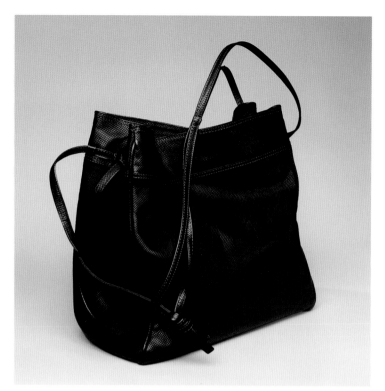

BOTTEGA VENETA
Black faux-lizard leather handbag with drawstring
closure, c. 1990s. Lent in Memory of
Sally Solomon. Photograph by Irving Solero

BOTTEGA VENETA
Evening clutch bag in silver woven leather with
matching coin purse, 1966. The Museum at The
Fashion Institute of Technology, Gift of
Beatrice Renfield, 98.102.4.
Photograph by Irving Solero

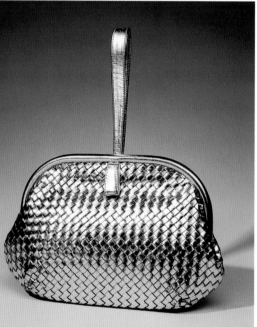

CESARE PACIOTTI
Fall/Winter 2002.
Photograph by
Mario Sorrenti. Courtesy
of Cesare Paciotti

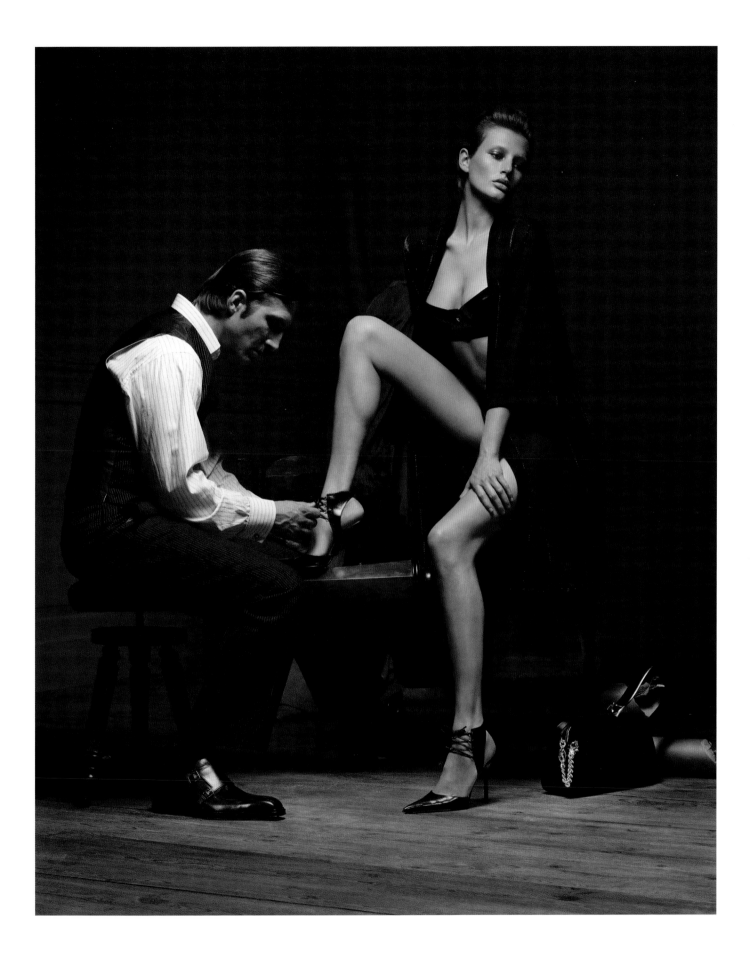

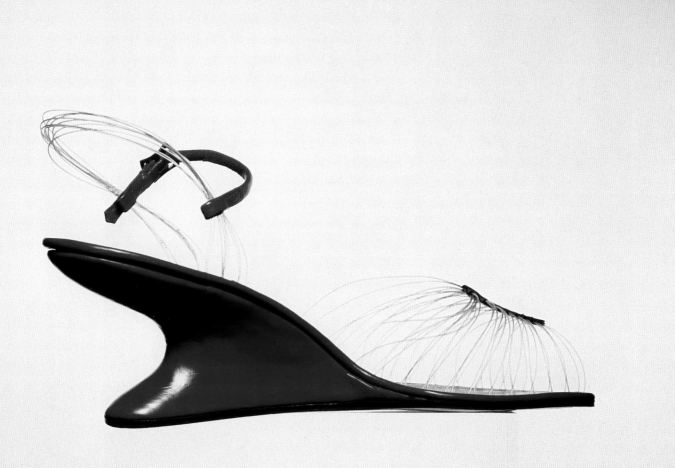

SALVATORE
FERRAGAMO
Shoe-print silk scarf in
black and cream, c. 1980s.
Lent in Memory of Sally
Solomon.
Photograph by Irving
Solero

SALVATORE
FERRAGAMO
Shoe-print silk scarfs in
yellow tones and navy,
c. 1980s. Lent in Memory
of Sally Solomon.
Photograph by Irving
Solero

Images of Italian Fashion

Fashion today is not only about designing and manufacturing clothes; it is also about communicating an image. After Miuccia Prada took charge of her grandfather's company, her first big success was a black nylon backpack with a triangular silver label. Soon her designs became the focus of a veritable cult of fashionistas. Words used in the fashion press to describe the Prada frenzy included obsession, addiction, and epidemic.

Prada clothes and accessories have been described as classic but also eccentric, frumpy, yet undeniably hip. The *New York Times* (7 April 1995) summarized the Prada phenomenon with the headline "Cool Rises to Intimidating Heights."

Prada clothes have been described as "uniforms for a really chic . . . army."[67] Miuccia Prada herself has said, "I have always thought that Prada clothes looked kind of normal, but not quite normal. Maybe they have little twists that are disturbing, or something about them that's not quite acceptable. Perhaps there's a bit of bad taste . . . Many people think our things are really awful. Does that disturb me? I have to say no. Because Prada is not clothing for the bourgeoisie."[68] Her secondary line, Miu Miu, also has subtle "misfit" connotations. Prada's collaborations with the architect Rem Koolhaas replicate the "techno/retro" ambivalence of her designs. Recently she has begun selling what she calls "vintage," that is, reproductions of select designs from past collections. Prada's style is modern, drawing on the northern Italian tradition of having discreetly elegant clothes beautifully made by local tailors and dressmakers.

facing page

DOLCE & GABBANA
Photograph by
Steven Meisel, courtesy of
Dolce & Gabbana

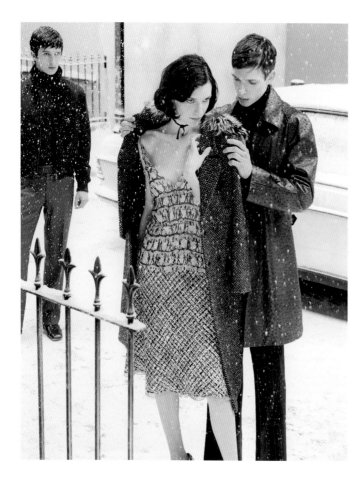
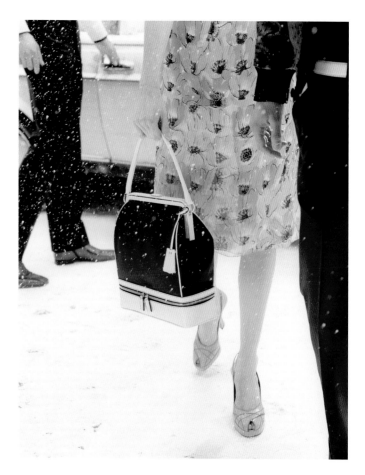

above left and right

PRADA
Advertising campaign for Fall 2000. Photographs by Robert Wyatt,
courtesy of Prada

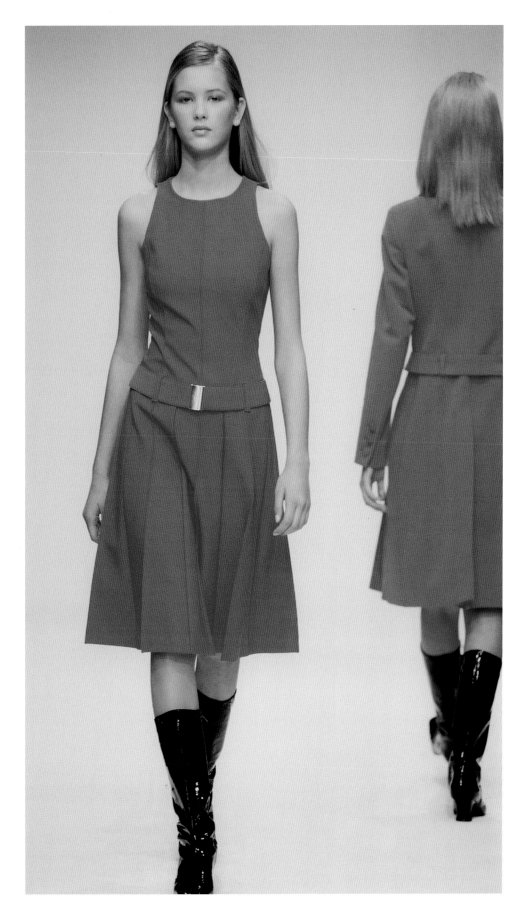

PRADA
Fall 1995. Photograph by
Maria Chandoha Valentino

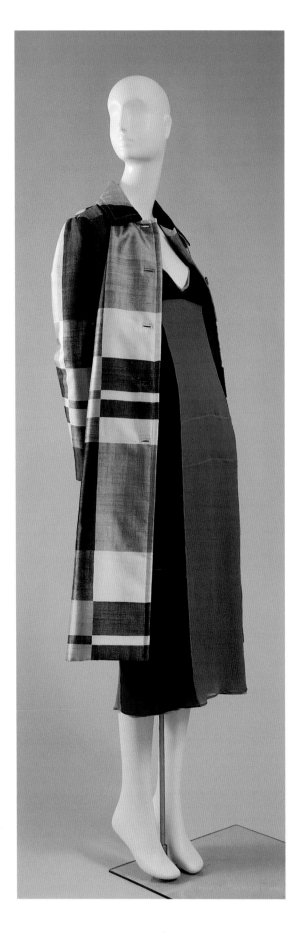

above

PRADA
Knapsack. Courtesy of Prada. Photograph by Irving Solero

left

PRADA
Dress and coat, 1997. Courtesy of Prada. Photograph by Irving Solero

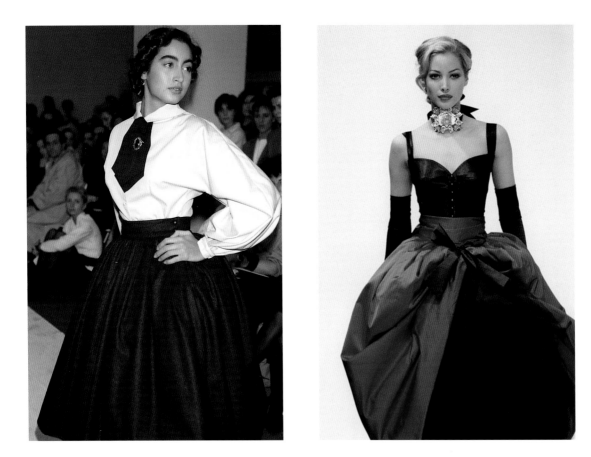

By contrast, Domenico Dolce and Stefano Gabbana skyrocketed to fame with their southern Italian sex-bomb look. Dolce was born in Palermo, Sicily; Gabbana was born in Venice. They founded their company in Milan in 1982 with an initial investment of $1,000. "By 2005 we should reach the one-billion-euro mark," says Gabbana.[69] If Prada is cool, Dolce & Gabbana is hot. They espouse a style of voluptuous femininity, inspired by pin-up girls and fiery Italian stars such as Sophia Loren and Gina Lollobrigida.

Dolce and Gabanna's fashions and advertising draw on film images of sexy Sicilian widows and bandits, and glamorous film stars straight out of *La Dolce Vita*. Steven Meisel's photographs have played a vital role in making the Dolce & Gabbana style internationally famous. Among the first designers to emphasize corsetry, they have consistently emphasized lingerie looks. Other recurrent themes in their work include leopard and zebra prints, glamorous curvy dresses, and not-for-the-office pin-striped suits. Beginning in 1990, they have also designed menswear, which is produced by skilled Sicilian tailors, supervised by Dolce's father. The menswear has also been highly successful internationally, projecting an image of sexy glamour. They too have spawned a younger, less expensive line, D&G.

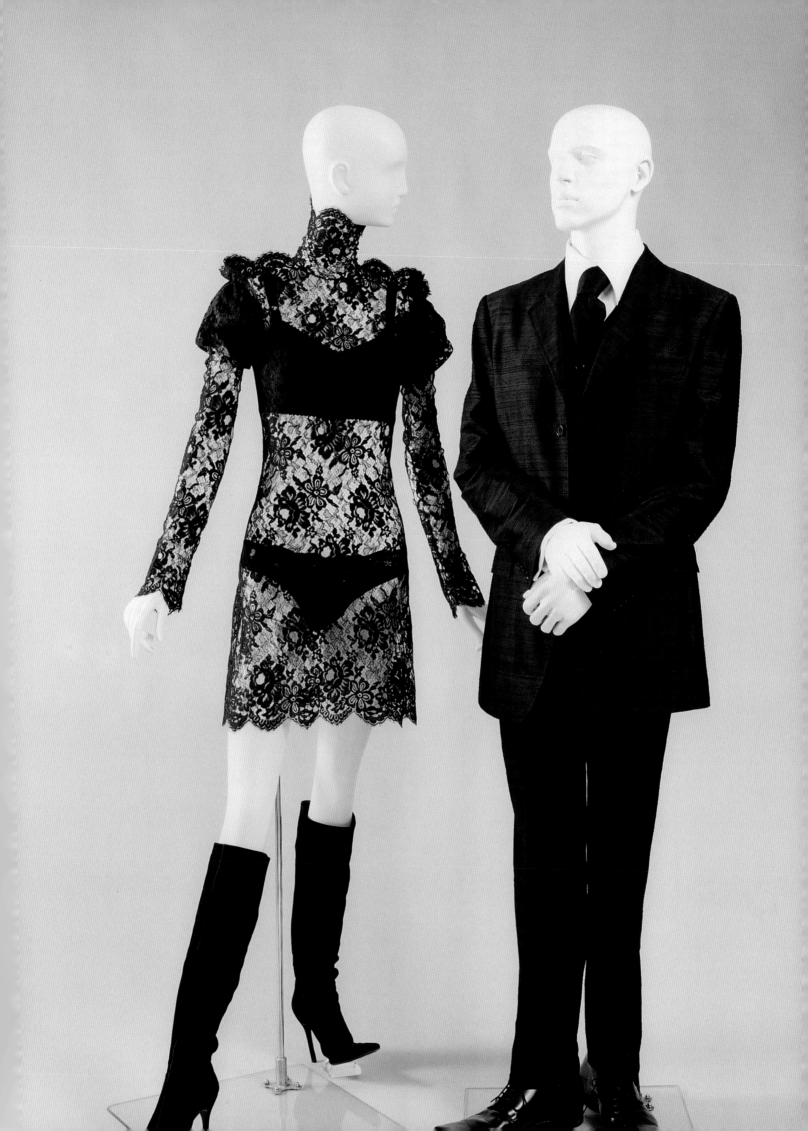

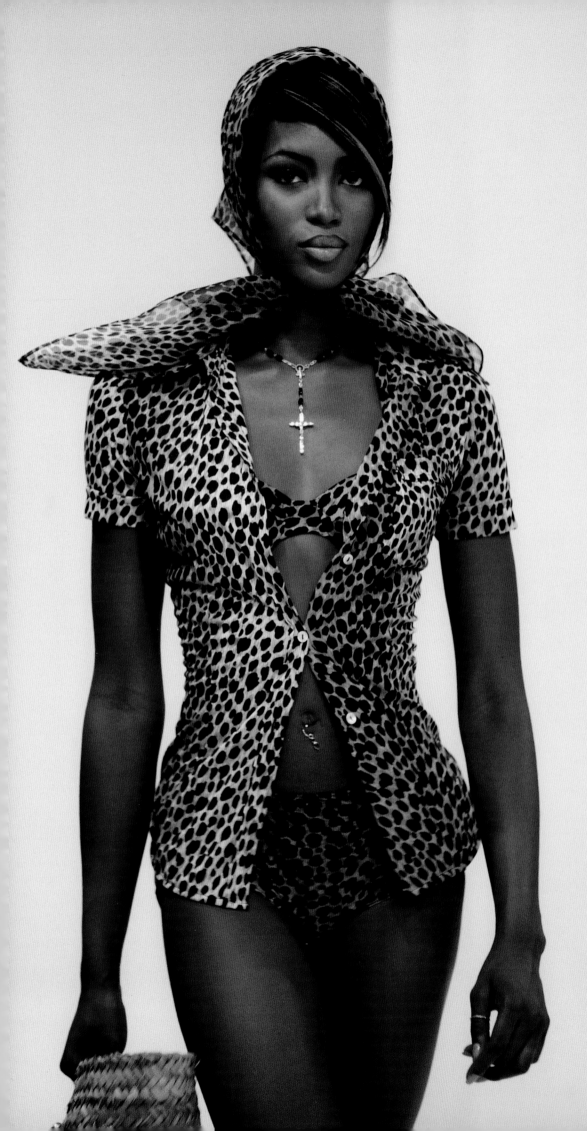

left

DOLCE & GABBANA
Spring 1996. Photograph
by Maria Chandoha
Valentino

facing page

DOLCE & GABBANA
Spring 2000. Photograph
by Maria Chandoha
Valentino

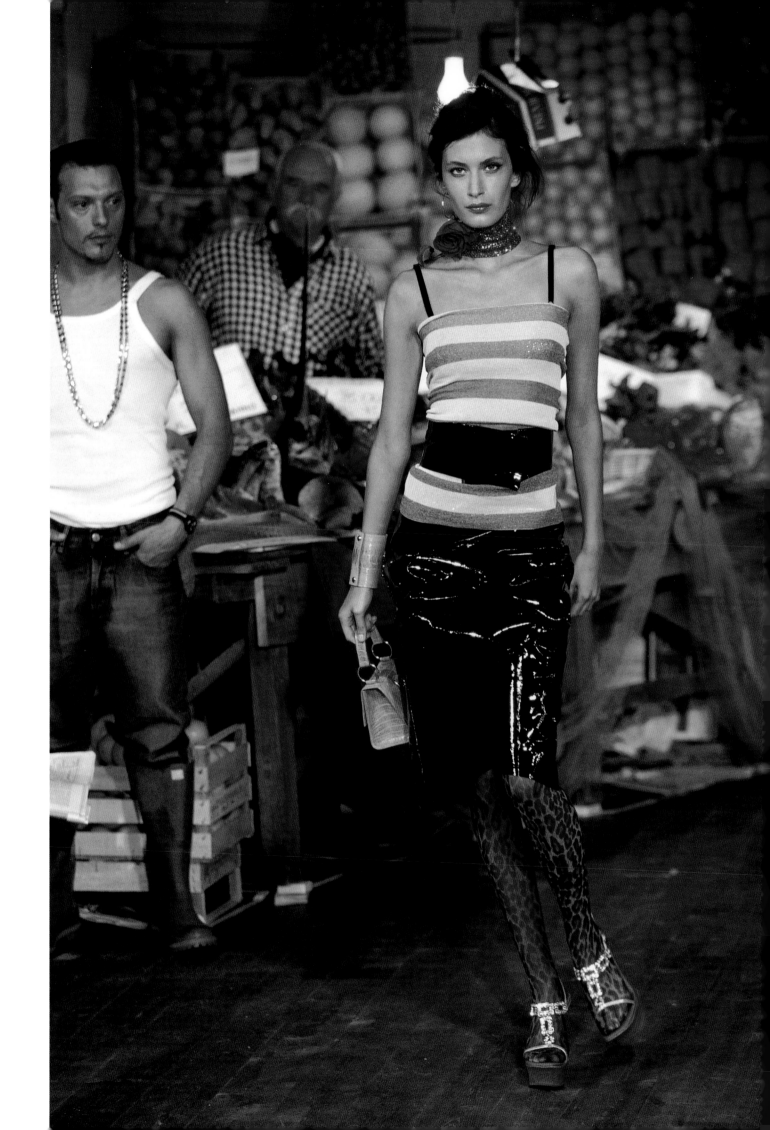

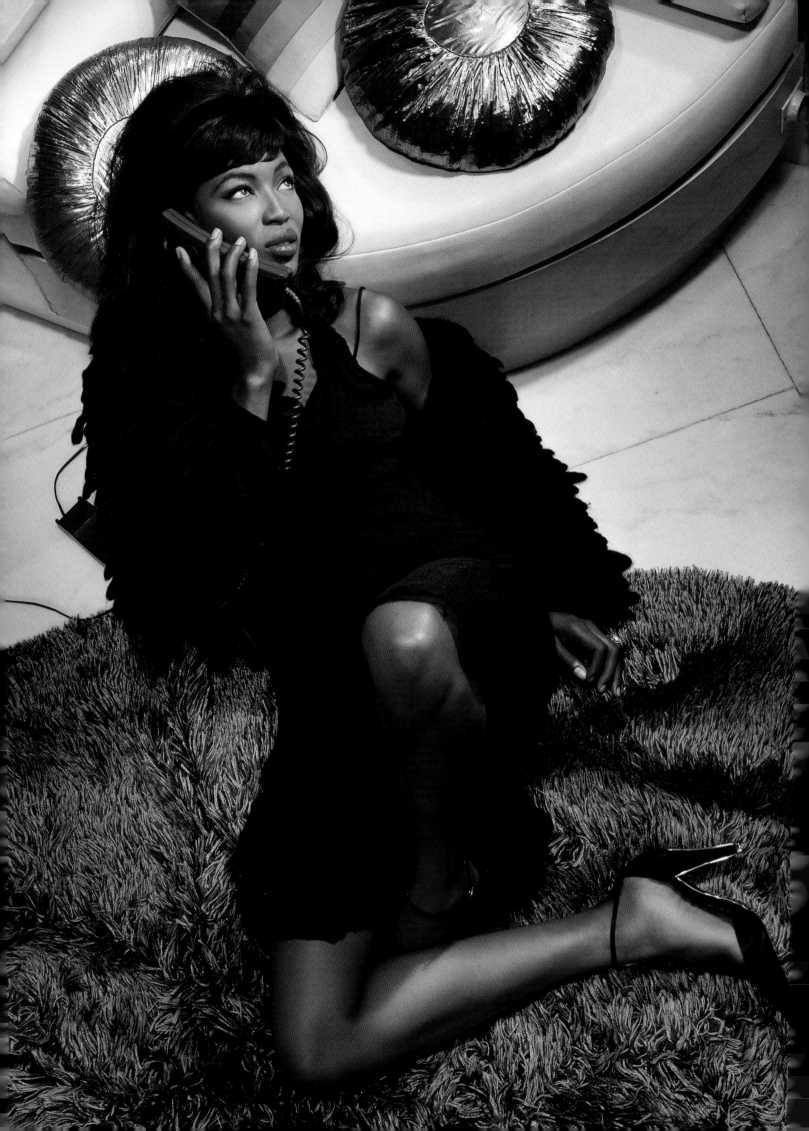

Vogue Italia is widely regarded by industry professionals as the best and most beautiful fashion magazine in the world. "We take more risks," explains the editor-in-chief, Franca Sozzani: "We have worked a lot on the image of the magazine, and tried to give it a unique style, so it will be immediately recognizable as *Italian Vogue*." She insists, however, that there is no longer any one Italian Look, as there might have been in the late 1970s. Rather, there are today many different looks, both in Italy and all around the world, "because people are more free, and they want to make their own choices." Asked to define what makes Italian fashion special, Sozzani suggests that Italy is perhaps "the only country that successfully combines a high degree of creativity and consistently high quality in making the clothes."[70]

Creativity is universal, but the marriage of traditional craftsmanship, innovative design, and modern industrial technology is rare. The success of the Italian fashion system is complex and overdetermined. The Italian model is based on a particular type of industrialism linked to Italian culture. It involves the advantages of decentralization, such as small, highly specialized workshops scattered throughout the Italian peninsula, and the advantages of centralized organizations that have greater ability to market and export products. The close collaboration between designers and manufacturers is crucially important. Consider, for example, a new talent from Milan, the Naples-born creator of unfrilly femininity Alessandro Dell'Acqua. Early in his career, Dell'Acqua established a close relationship with a group of artisans at a small mill near Bologna. "It was like they adopted me when I was a child in this business," he says, crediting the artisans with the extraordinary delicacy of his hand-finished knits.[71] So, perhaps, the secret does lie in the contemporary equivalent of "that fine Italian hand" – the place where art and technology unite.

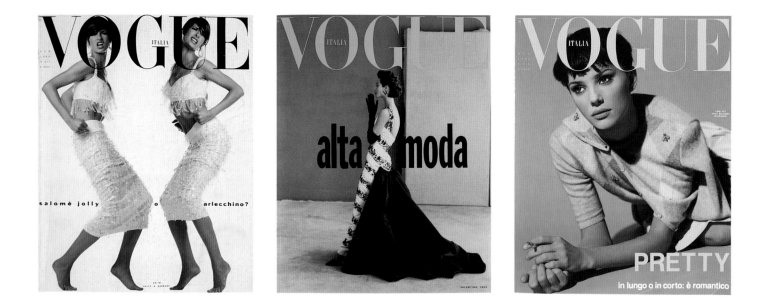

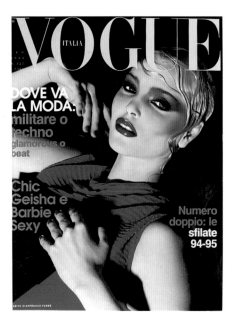

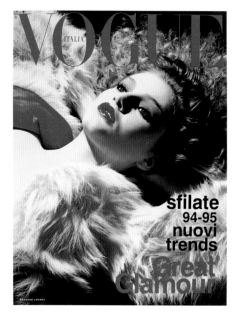

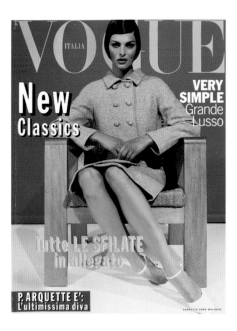

Vogue Italia

top February 1990; March 1991; October 1993
bottom July 1994; Autumn/Winter 1994–95; July 1995

Courtesy of *Vogue Italia*

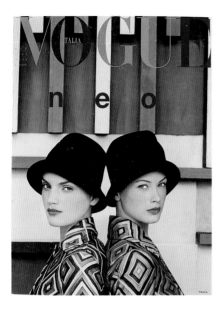
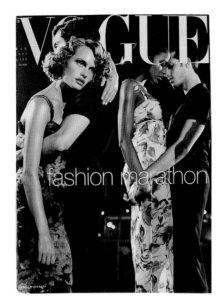
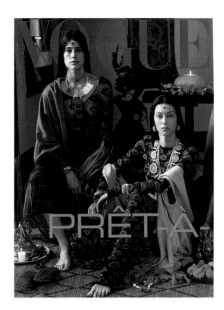
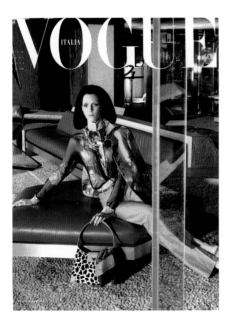

Vogue Italia

top October 1996; March 1997; September 1999

bottom left March 2000

Courtesy of *Vogue Italia*

L'Uomo Vogue

bottom centre and right October, 2000; October, 2002.
Courtesy of *Vogue Italia*

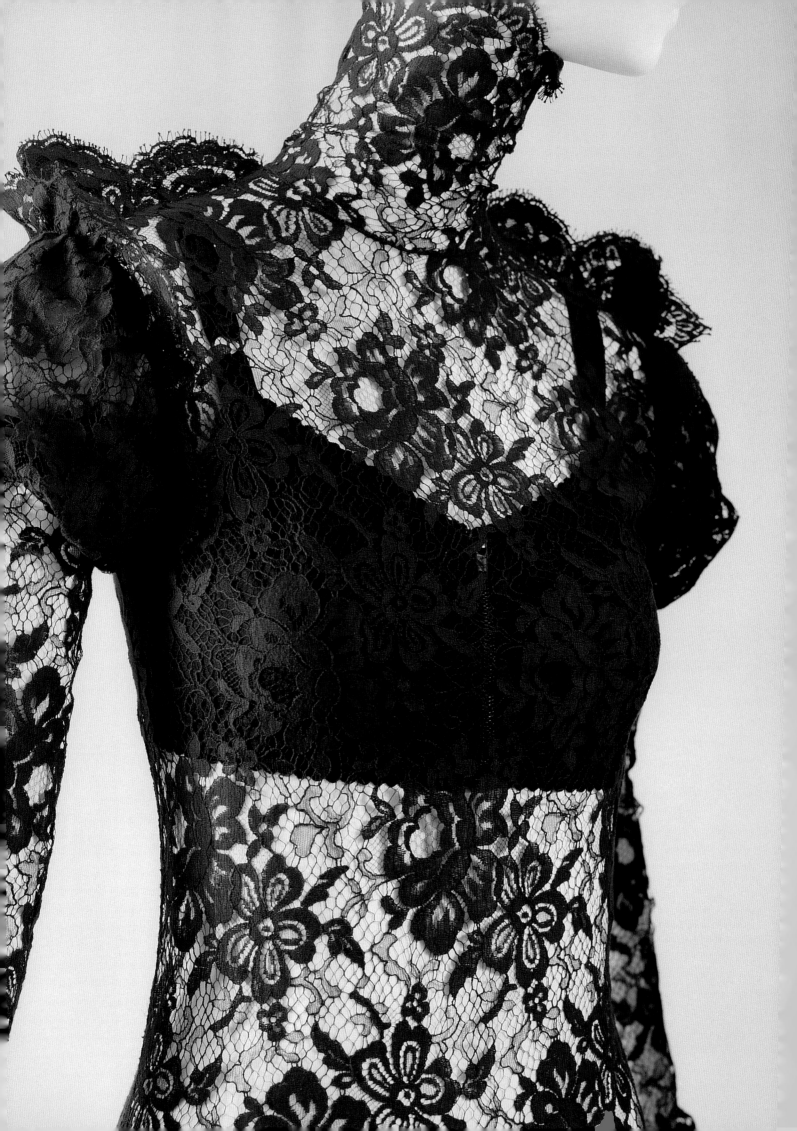

The Material Speaks for Itself

SIMONA SEGRE

The colors, shapes, and designs of the fabrics and materials of the Italian fashion industry bring to mind nothing so much as the textures, sinuosity, luminescence, and velvety surfaces of exotic fish or tropical coral reefs. Strange and beautiful forms from the vegetable and animal worlds are revealed in infinite variety to the eyes of those who plunge into the realm of the textiles of Italian clothes and accessories.

Italians have been textile producers for centuries, and have been major consumers of precious materials as well. They are among Europe's leading purchasers of cashmere and fine wool knitwear, in which they sensually wrap themselves. The manufacturers who work with these precious materials are highly specialized, and search for the finest raw materials from Australia to China and South America, to which they apply their aesthetic and technological know-how. The names of several companies that work with cashmere, such as Annapurna, Gentry Portofino, Fissore, and Malo, have become synonymous with luxury, softness, and good design.

The world of Italian textiles is one of great riches and tradition. In the Middle Ages the textile business was financed by merchant bankers, who then sold the finished product to markets throughout Europe, the Middle East, and the Far East. Inevitably, the first centers for Italian textiles sprang up near the four great maritime

republics: Venice, Genoa, Pisa, and Amalfi.[1] The Italian economy was predominantly agricultural from the twelfth through the seventeenth centuries, but the handicraft trades linked to fibers, in particular silk and wool, were actively encouraged.

The success of the Italian fashion industry is inextricably linked to Italy's success in innovations in the textile and fabric industries. Whether because of the textile trade that was already flourishing in the Middle Ages, even before textile machinery was introduced on a large scale from France and England, or because of the relationships that developed among textile producers and their ability to tune into the needs of the new generations of designers, it was through the accessibility of textiles that the riches of Italian prêt-à-porter (ready-to-wear) were able to be created. Nancy Martin defines it as "the friendly collaboration between designers and textile industrialists."[2] This collaboration began as early as the 1950s, well before the new category of designers inserted itself between high fashion and the garment industry, as Nicola White has pointed out in her essay on evolution of the Italian fashion industry after the Second World War.[3]

The central role of fabrics in Italian fashion was in part also owing to a longstanding appreciation of traditional crafts such as embroidery- and lace-making which had been used primarily in Italian high fashion: "The triumph associated with of Italian design encompassed Terragni's muslin and taffeta, Val di Susa's cottons, the handprinted fabrics of Rivetti Lini e Lane, Falconetto's designs derived from home furnishing textiles, satin shantungs, silk poplin 'japons,' and embossed repoussé satin made by Como textile producers such as Ambrosini, Cugnasca, Stucchi, and Toninelli."[4]

This long-established textile tradition, extending over much of the country, was probably influential in creating the large quantity of firms that exists today: of the total number of European fashion businesses, one out of every two is Italian. The extent of the textile industry was responsible also for the culture of "geographical location," whereby fashion areas developed into industrial districts or clusters, and more specifically, for the so-called "integrated network." Quite often, a fashion project begins with the thread and ends with finding the right button – not a difficult thing to do in Italy.

The list of districts, from the oldest to the more recent, would cover pages, and even the highly specialized areas have historical roots. For example, "Button Valley" in and near Bergamo, the source of fifty percent of Italian buttons, dates back to the 1800s when corozo (the albumen extracted from the seeds of certain species of tropical palm trees found in South America) was transformed and made into a vegetal "ivory." Details often make the difference in an article of clothing, and buttons can "make" a shirt. Men's shirts, for example, must have between ten and twelve four-holed buttons, sewn at three points, like the three-leaf lily, symbol of Florence.

For the silk companies of Como, heirs to a tradition, that had traveled from Lombardy and Piedmont, the silk is imported primarily from China – silkworms are still not bred in Italy. The best silk textiles come from Como, which remains unsurpassed in its dying, finishing, and above all printing and photoengraving techniques. The last specialization dates from 1880 when it was invented by dipping engraving blocks or plates in ink, upon which was placed, in relief, a motif made of pearwood or a thin plate of brass or tin and lead alloy.[5] In the Como area, some of the many noteworthy names that have created this silk legacy are Ratti, Mantero, Canepa, Boselli, and Marioboselli.

Biella, on the other hand, is synonymous with fine woolens. "The patriarchs of Biella are the great wool industrialists. Families that go back fifty to one hundred years or more are running the wool industries there, consisting of entire family trees whose branches extend to wool combing, carding, yarn spinning, and textile mills.[6] In this area, the most famous firms include Zegna, Loro Piana, Cerruti, Carlo Barbera, and Agnona, among others.

Manufacturers producing a different type of woolen product are located in Prato, continuing a historical link with medieval and Renaissance Florence and the rest of Tuscany. The material, originally called "Florentine cloth," later evolved into the regenerated wool typical of the Prato area. With the arrival of ready-to-wear, Faliero Sarti and other Prato companies took the initiative during the 1980s by renewing their product lines and using various fiber blends and special finishes.

The processing of leather has a different history from that of textiles. While the great tradition of natural tanning originated in France, Italy has for years been specializing in treatments for and experiments with hides. As a result, accessory designers these days have a vast range of products available from which to choose, in a field as large as that of textiles.

About half of leathergoods exports originate in Tuscan tanneries, centered on Prato, Empoli, and, Valdarno, and Tuscany is the headquarters of companies such as Prada, Gucci, and Ferragamo. Footwear manufacture, another major sector renowned for its "Made in Italy" tag, is also spread throughout the country – for example, in the Veneto, Vigevano, the Marche, and Emilia Romagna (San Marco Pascoli). A famous name that has emerged from a family leather business is that of Diego Della Valle, founder of Tod's. His father began by making shoes in the kitchen of his home, and then developed the business, working first with his wife and later involving his sons.

The success of Italian footwear is a prime example of the powerful combination of high quality in the raw materials and fine workmanship. Designers today are purchasing some of the old footwear factories to ensure that they have access to the kind of experience that is difficult to acquire from scratch. Moreover, it appears that older, retired Italian leather craftworkers are very much in demand by Asian

companies who hire them for a limited period, usually a year or two, to draw on their expertise. Companies in Southeast Asia are striving to gain the knowledge necessary to work with leathergoods and emulate the "love for the product" shown by Italian artisans. This "love" is characteristic of the Italian footwear industry, for example, and unsurprisingly, Italy is the world's leading footwear exporter. In addition, foreign companies are purchasing capital goods – machinery – from Italy, which with Germany is Europe's largest exporter of textile machinery.

Knitwear, unlike the geographically widespread footwear sector, is centered on Treviso and Carpi. The fashion district of Carpi is a fine example of an area that made a rapid transformation from an agricultural to an industralized economy.

The fashion districts now feel the competition from those countries with a cheap labor force, and its adverse effects are combated by continual innovation and ever more sophisticated production methods and products, which are harder for competitors to match or copy. Fashion is, however, a naturally competitive or emulative phenomenon, as is evidenced by, for example, the "trickle-down" effect, the first theory about the way in which fashion spreads. It is highly unlikely that it has anything to do with class rivalry, as nineteenth-century sociologists proposed, but rather with an aesthetic of seduction, or as Valerie Steele put it, "as an aesthetic vehicle for fantasy."[7]

Even though the Italian textile industry used almost exclusively only natural fibers until the early 1900s – a characteristic that is still strongly identified with "Made in Italy" – beginning in the 1930s artificial fibers came into use, and since the 1960s, synthetic and microfibers, as well as synthetic yarns and above all blends, have been added, which marks an evolution in Italian textiles: linen with silk and nylon, chenille with wool, cashmere and silk, and so on. Innovative, hi-tech fabrics have been developed, including coated fabrics, coagulates, resinated fabrics, and new inventions such as "snakeproof" fabric, which has a coated Kevlar base of polyurethane and carborundum that is equal in resistance to a synthetic diamond. This product is geared to trekkers or those who might encounter unexpected dangers in rugged, outdoor activities.[8]

Often fashion evolves with an ebb and flow, both for natural and manufactured fibers. There are upswings, rediscoveries, declines, and rebirths of this or that fabric. But when a particular fabric returns to favor and becomes "in" again after a period of neglect or oblivion, it is never exactly the same as it once was: it has undoubtedly undergone a series of processes that transform and enrich it with noticeable new qualities that suggest new applications and possibilities.

From the archives of the great textile producers, new proposals have emerged such as the 2002/03 "Wunderkammer" collection from Solbiati of Como, one of the leading textile companies to have collaborated closely with designers in the

mid-1970s. The collection consisted of "100 products conceived around the nature of the fundamental weave of the fabric: drill, satin, piquet, panama, and gabardine. These weaves are constructed with very fine yarns – mostly cotton blended with silk, wool, or cashmere."[9] Or consider the "Heritage" line by Zegna which reexamines fabrics of the Biellese pedigree and those created in-house, while making them lighter and maintaining the aesthetic content intact.[10] The Ratti Foundation, founded by Antonio Ratti, a Como silk entrepreneur, in addition to promoting research in the field of textile production, is restoring and cataloguing a collection of antique fabrics, nearly 400,000 items gathered by Ratti during thirty years of business. In a recent collection, Etro has drawn upon its classic fabrics and mixed them in a fresh new way. It is in this way that the most precious fabrics are created, such as the unique, extremely thin yarns with a hand finish almost like crochet made by Cristiano Fissore, a company whose specialty is cashmere.

There has also been a trend toward combining different materials; for example, CP Company combines rubber and wool in a line of hi-tech jackets, and a super-stretch outfit using monofilament nylon. Or, the recent Marzotto "molded" line features a new method of processing fabric, from the twisting of the yarn to the finish, which can be applied to wool as well as wool-silk and wool-mohair blends. Then there are the handbags of Luisa Cevese, a designer who, after gaining experience at Ratti in Como, has been producing her own line of accessories created by recycling textile scraps and pairing them with plastic. The items are similar in appearance, but each is actually unique.

A return to all but forgotten traditions has been made in several regions such as Sardinia. Inspired by such traditions, the designer Antonio Marras and some artisan workshops have reintroduced the production of traditional silk and wool embroidered shawls, all painstakingly handmade.

In Padua a small company, Sommerso, is offering a new take on Venetian handicrafts. It uses Murano glass beads, for example, to create one-of-a-kind accessories such as handbags, buttons, and hair ornaments for bridal and evening wear, in keeping with the historical functions of Venetian glass beads, and much as Fontana Sisters did in its time.

This is also an important tie for hemp, a fiber that is cultivated primarily in northern Italy. In the past it was put to many uses, but only recently, following a long period of neglect, has it once more generated interest among designers. Simint, the manufacturer of Armani Jeans, is an active member of Canapaitalia, which has plans to produce a large quantity of hemp in new plantations on the fertile plains between Ferrara and Bologna.[11]

Such developments mark not only a rediscovery of fibers, but also a cultural homecoming. Just as the materials being used reflect styling, tailoring, and design,

so they mirror the evolution of the designer, the consumer, and the means of production. In the 1980s, Romeo Gigli, going against the mainstream as well as being a pioneer, relaunched corduroy in his menswear collections. Wide-wale corduroy, which had disappeared along with the student protests of the 1970s, was offered anew in a style emphasizing intellectual masculinity and different from the more managerial look then prevalent.

Experimentation is fundamental in Italy for fabrics and materials, and research is a basic element of the "Made in Italy" textile tradition – experimentation, creating new hybrids, and innovative finishes. The professional figures bringing newfound glory to textiles are individuals who draw upon their experience and knowledge of fibers, the various components of materials, and technological trials and tests to develop new applications. Italian textiles these days represent above all research and transformation. Companies such as Limonta, founded in 1893, have always been on the cutting edge. With its renowned finishes and its research into special fabrics geared to various uses, serving both the fashion and home furnishing industries, Limonta is a benchmark for all those who work with fabric and other materials.

Fabric research involves experts located all over the world. Alcantara, for example, was invented in Japan yet is made in Italy. A special laboratory for experimenting with this leather-like substance, from which the company derives its name, has been established in Umbria. Enka, a German manufacturer of viscose yarns, became a member of the Camera Nazionale della Moda Italiana and opened a fashion center in Milan geared to designers who wish to experiment and work with viscose yarn. Then there is the "Biella Master of Noble Fibers," a school founded in the early 1990s by a group of leading companies from the Biella area with several prestigious European and American trademarks. Its purpose is to create a managerial class devoted to striving for excellence in the textile and fashion sectors. And Material ConneXion, with offices in New York and Milan, is a unique service for those researching or looking for new materials. Originally founded to serve the construction and building trades, the medical field, and hi-tech sectors, it has become a frequent source for textile and fashion designers looking to launch new projects.

★ ★ ★

Fabric and materials are beginning to make themselves heard. Fabric speaks to us, and its language is more seductive and current than trademarks or place names, which recently have been labeled "out of fashion."[12] Expressing personal taste by favoring a particular trademark or designer is too simplistic to be a true sign of competence, as Bourdieu taught.[13] Moreover, trademarks are easily imitated. The world of designer labels has been mobilizing in recently years to combat imitations, copies, and knock-offs – parodies, even. Court cases involving "Intellectual Property Rights" (IPR) have

become ever more frequent in the fashion world. Even styles and trends are subject to imitation, overstepping research. The production revolution of ready-to-wear fashion, a point of arrival for the democratization begun in the ear of "open fashion," as Lipovetsky defines it,[14] has thrown the canonical production times and the very concept of trends into crisis.

Materials surface with their personal, calm, profound truth made of history, creativity, and civilization, and the products inspired by materials are in perfect harmony with design. Companies are rediscovering that giving a voice to material can be a sure way to explain and defend the quality of their products.[15] Luxury is also defined by it success in evoking other worlds by the mere mention of certain names. Thus the material itself speaks to add strength to the brand name, which on the basis of a logo alone cannot affirm itself as vigorously.

A new type of communication, which is carried out directly on the product and through the fabric, is discovering a new path, alongside traditional advertising. The yarn itself is not only a product that gains value when it becomes part of a finished item, but is capable of stirring up desire and interest on the part of consumers, as a recent essay about cashmere indicates.[16] The evolution of the label as a card tag attached to articles of clothing in stores is an example of this. The typically dull but necessary care instructions ("wash at a temperature of 30 degrees, do not spin-dry, wash item separately"), accompanied by the internationally accepted codes, have given way to brief poetic compositions. They are somewhat like a textile haiku which has been given the task of telling the story of the garment via the highly imaginative description of the fabric, including the care instructions necessary for preserving it. Here are some enjoyable examples of textile haikus that appeared on Prada items in Fall 2002[17] on display at Corso Como in Milan:

> This garment of a very light silk voile is characterized by twill appliqués. Given the sophisticated nature of the garment and the elaborate structure of the fabric, a certain degree of care should be taken during use, especially when wearing rings, bracelets, watches, or other items that might snag the garment. [Label on fir-green chiffon blouse.]

> This garment is made of a light jersey of silk, cashmere, and cotton, characterized by subtle irregularities given by the inclusion of silk. Gentle dry cleaning will be the best way to preserve the original properties of this specific garment. [Label on jersey voile blouse.]

> This garment made of wool fabric with a twill weave is characterized by a diagonal pattern created by the interplay of warp and weft threads. If handwashing is indicated, wash separately in cold water with the garment turned inside out. Otherwise gentle dry cleaning will be the best way to preserve the original properties of this specific garment. [Label on a coat.]

Another way in which fabric speaks is by intentionally exposing the seams and stitches, or by reliefs and irregular buttons and edges – a material hyperbole that glorifies the 'defect," transforming it into a merit. The living, unique, inimitable article

of clothing reveals itself through the loquacious nature of the material, which chooses not to conceal anything, but rather to show off what was previously considered an "imperfection."

"Some characteristic features of the fur, such as slight variations in its thickness/density, or minor nuances in shading, are due to the individual animal itself and should not be considered defects, but rather as inherent features of natural products." This sentence appears on the labels of fur jackets made by Dolce & Gabbana, proclaiming and ennobling the variations from one item to another, and emphasizing the origins of the animal from which the fur comes. The original material is not always obvious or detectable in modern industrial times. The same goes for salvaged material, which is processed by artisans and used to create individual, one-of-a-kind items. Designers and craftworkers have also discovered textiles and other materials behind the scenes of fashion-trade shows and have utilzed them to speak directly to the public with their evocative language of luxury, highly skilled work, and research.

For Italian fashion, these developments mean a kind of return to its origins. But fashion, a postmodern art by definition – probably because it shares the ambivalence[14] of the postmodern movement – is capable of transforming the past, present, and future into erratic and fortuitous narrative tales. Therefore, perhaps it can be seen as a simple return to the future: "the future of fashion?" Minnie Gastel asked Vittorio Solbiati. The response was, "as for prêt-a-porter, there's no doubt about it. The leadership role will remain with Italian textiles."[18]

Notes

1 Luigi Settembrini, quoted in Gino Malossi, ed., *La Regola Estrosa: One Hundred Years of Italian Male Elegance*. Milan: Electa, 1993, p. 11.

2 Ibid., p. 37.

3 Futurist manifestos and Balla, quoted in ibid., pp. 67–70.

4 Ibid.

5 Ernesto Crispolti, "The 'Futurist Reconstruction' of Fashion," in Germano Celant, ed., *Art/Fashion*. New York: The Guggenheim Museum, 1997, p. 51.

6 Elsa Schiaparelli, quoted in Valerie Steele, *Paris Fashion: A Cultural History*. New York: Oxford University Press, 1988, p. 269.

7 *Bellezza* (September 1942), quoted in Nicola White, *Reconstructing Italian Fashion: America and the Development of the Italian Fashion Industry* (Oxford: Berg, 2000), p. 77.

8 Ornella Morelli, "The International Success and Domestic Debut of Postwar Italian Fashion," in Gloria Bianchino et al., eds., *Italian Fashion*, vol. I: *The Origins of High Fashion and Knitwear*. Milan: Electa, 1987, p. 58.

9 White, *Reconstructing Italian Fashion*, p. 5.

10 Marya Mannes, "Italian Fashion," *Vogue* (January 1, 1947), p. 119.

11 Ibid., pp. 119, 155.

12 "Italian Ideas for Any South," *Vogue* (November 15, 1951), p. 124.

13 Bonizza Giordani Aragno, "The Mirror's Role in the Atelia," in Bianchino et al., *Italian Fashion*, vol. I, p. 98.

14 "Italy Gets Dressed Up," *Life* (August 30, 1951), pp. 104–12.

15 *Paris-Presse* (August 6, 1951), p. 1.

16 "The Good Word on Italy – and Italian Fashion," *Vogue* (April 1, 1961), p. 135.

17 Bettina Ballard, *In My Fashion* (London: Secker and Warburg, 1960), p. 244.

18 Giovanna Lazzi, "Lights and Shadows in the Sala Bianca: Florence, Fashion and the Press," cited in Bianchino et al., *Italian Fashion*, vol. I, p. 74.

19 "Italian Imports," *Life* (April 14, 1952), p. 89.

20 Nicola White, *Reconstructing Italian Fashion*, p. 159.

21 "Italian Collections Notebook," *Vogue* (September 15, 1952), p. 154.

22 "Dramatic Decade of Italian Style," *Life* (December 1, 1961), pp. 66–69.

23 Quoted in Samantha Conti, "The Italian Conquerors," in *Women's Wear Daily* (September 28, 1998).

24 "Italian Collections Notebook," *Vogue* (September 15, 1952), p. 155.

25 Quoted in Taryn Benbow-Pfalzgraf, ed., *Contemporary Fashion*, 2nd ed. Detroit: St. James Press, 2002, p. 99.

26 *Life* (August 30, 1951), p. 108.

27 Virginia Pope, *New York Times* (July 24, 1954), and Eugenia Sheppard, "Countess Visconti Here With Collection For Bergdorf Goodman," *New York Herald Tribune* (November 14, 1951), in the Simonetta File at the Costume Institute, The Metropolitan Museum of Art, New York.

28 *Life* (August 30, 1951), p. 110.

29 *New York Times* (October 19, 1955), p. 37, and *New York World Telegram and Sun* (September 22, 1955), p. 20.

30 "Italian Collections Notebook," *Vogue* (September 15, 1952), p. 201.

31 "Bonjour Paris, Adio Rome, Say Couture Duo," *Women's Wear Daily* (April 3, 1962), p. 1.

32 "Forquet in Anticipo," *Women's Wear Daily* (July 19, 1966), p. 14.

33 "The Men's Pages: Summer Basics from Italy," *Vogue* (April 1, 1956), p. 100.

34 "The Italian Man," *Life* (August 23, 1963), pp. 55, 56, 58.

35 See Chiara Giannelli Buss, "Stylism in Men's Fashion," in Grazietta Butazzi and Alessandra Mottola Molfino, eds., *Italian Fashion: From Anti-Fashion to Stylism.* Milan: Electa, 1987, p. 232.

36 David Bowie, quoted in Kurt Loder, "Stardust Memories," *Rolling Stone* (April 23, 1987), p. 80.

37 Walter Guzzardi, "Boom Italian Style," *Fortune* (May 1968), pp. 137–39.

38 "Battle of the Pitti Palace," *Newsweek* (August 2, 1965).

39 Richard Martin, "Missoni," in Benbow-Pfalzgraf, *Contemporary Fashion,* p. 474.

40 Mariuccia Mandelli, quoted in Silvia Giacomoni, *The Italian Look Reflected.* Milan: Mazzotta, 1984, p. 104.

41 Interview with Franca Sozzani, September 10, 2002.

42 John Fairchild, quoted in Giacomoni, *Italian Look Reflected,* p. 113.

43 "The Italian Look," *Newsweek* (October 22, 1978), p. 136.

44 Beppe Modanese, quoted in Giacomoni, *The Italian Look Reflected,* p. 95.

45 Nino Cerruti, quoted in Christopher Dickey "Armani After All," *Newsweek* (September 3, 2001), p. 50.

46 Jay Cocks, "Suiting Up for Easy Street: Giorgio Armani defines the new shape of style," *Time* (April 5, 1982), p. 60.

47 David Pryce-Jones, "Giorgio Armani's Fine Italian Hand: The Rich, Relaxed Style," *Esquire* (May 22, 1979), p. 37. See also in the same issue of *Esquire:* Rita Hamilton, "Easy and Elegant New Clothes Men Like," p. 31.

48 Woody Hochswender, "Images of Man, Labeled Armani," *New York Times* (December 21, 1990), p. C36.

49 "The Case of Giorgio Armani," in Giacomoni, *Italian Look Reflected,* p. 67.

50 Judith Thurman, "A Cut Above: Giorgio Armani's Cool, Cool Elegance," *Connoisseur* (August, 1988), p. 92.

51 Giovanna Grignaffini, "A Question of Performance," in Butazza and Molfino, *Italian Fashion,* p. 24.

52 *W,* quoted in Lois Perschetz, *The Designing Life.* New York: Clarkson Potter, 1987, p. 152.

53 Samantha Conti, "Tailor Made," *WWW Italy The Fashion Makers* (February 2000).

54 Giorgio Armani, quoted in "Italian Lessons," *Esquire* (July 1999), p. 119.

55 Richard Martin, "Versace," in Richard Martin, ed., *Contemporary Fashion,* 1st ed. Detroit: St. James Press, 1995, p. 531.

56 Richard Martin, "Gianni Versace's Anti-Bourgeois Little Black Dress," *Fashion Theory,* vol. 2 (March 1998), p. 96.

57 "Franco Moschino Dies in Italy," *Women's Wear Daily* (September 20, 1994), p. 1.

58 Franco Moschini, quoted in Nadine Frey, "Franco's Follies," *Interview* (July 1989), p. 52.

59 Franco Moschini, quoted in Ben Brantley, "Designing Anarchist," *Vanity Fair* (March 1990), p. 78.

60 Luigi Maramotti, quoted in Benbow-Pfalzgraf, *Contemporary Fashion,* p. 458.

61 Franco Mattioli, quoted in Giacomoni, *Italian Look Reflected,* p. 99.

62 Gianfranco Ferré, quoted in Benbow-Pfalzgraf, *Contemporary Fashion,* p. 230.

63 Quoted in Giacomoni, *Italian Look Reflected,* pp. 108–09.

64 Mario Boselli, quoted in ibid., p. 147.

65 Ottavio Missoni, quoted in ibid., p. 90.

66 Adèle Fendi, quoted in Samantha Conti, "Fendi Frenzy," *Women's Wear Daily* (September 16, 1999), p. 24B.

67 Amazon.com review of *Projects for Prada* by Rem Koolhaas.

68 Charles Gandee, "1990s: Miuccia Prada takes stock of fashion on the precipice of the twenty-first century," *Vogue* (November 1999), pp. 189, 498.

69 Stefano Gabbana, quoted in *Daily New Record* (May 6, 2002), p. 9.

70 Interview with Franca Sozzani, September 10, 2002.

71 Alessandro Dell'Acqua, quoted in Annemarie Iverson, "Absolute Alessandro," *Harper's Bazaar* (August 1997), p. 75.

The Material Speaks for Itself

Thanks are due to Between Design Research, Daniela Puppa, and Tremelloni Library, Milan.

1 *Vision de la Toscane: Cinq siècles de textiles italiens*, ed. Rosalia Benito Fanelli, Electa, Florence 1983.

2 N. Martin, "Vicinanze: Fibra, tessuto, vestito," in *Il Motore della moda*, ed. G. Malossi. Fashion Engineering Unit, Monacelli Press, Florence, 1998, p. 2.

3 N. White, *Reconstructing Italian Fashion*, Berg, Oxford, 2002.

4 M. Gastel, *50 anni di moda italiana*, Vallardi, Milan, 1995, pp. 27–28.

5 E. Roncoroni, "Introduzione," in *La seta*, ed. E. Pifferi, special edition for Stamperia Maesani, Editrice EPI, Como, 1984.

6 P. E. Gennarini in *Biella*, ed. C. Brigidini and P. Tedeschi, Edizioni Condé Nast, Milan, 1990, n.p.

7 V. Steele, "Perchè la gente odia la moda," in *Il Motore della moda*, pp. 60–70.

8 *Trend*, no. 22, May 2002.

9 *Mood: Lo spirito delle cose – The Spirit of Things*, 32, 2002, p. 195–96.

10 R. Molho, "Alla ricerca della tradizione," *Il Sole 24 ore*, January 17, 2002.

11 M. T. Scorzoni, "Simint nel programma di riscoperta della canapa," *Il Sole 24 ore*, May 7, 2002.

12 The *New York Times* in September 2002 devoted an article to the crisis facing logos.

13 P. Bordieu, *La distinzione: Una critica sociale del gusto*, IL Mulino, Bologna, 1984.

14 G. Lipovetsky, *L'impero dell'effimero*, Garzanti, Milan, 1989.

15 Yet even materials are not free from the risk of imitation. For this reason a supervisory body, the Cashmere & Camel Hair Manufacturers Institute, has been set up with offices in Boston and Milan to uncover fraud in cashmere items.

16 F. Merlo "Un morbido filo di sole: Il cashmere per uomo di Baroni," in *Al di la' della moda*, ed. Lucia Ruggerone, Franco Angeli, Milan, 2001.

17 E. Wilson, "Fashion and the Postmodern Body," in *Chic Thrills: A Fashion Reader*, ed. E. Wilson and J. Ash, University of California Press, Berkeley and Los Angeles, 1992, pp. 17–24.

18 Gastel, *50 anni*, pp. 27–28.